BLACK AMERICA SERIES

KEY WEST

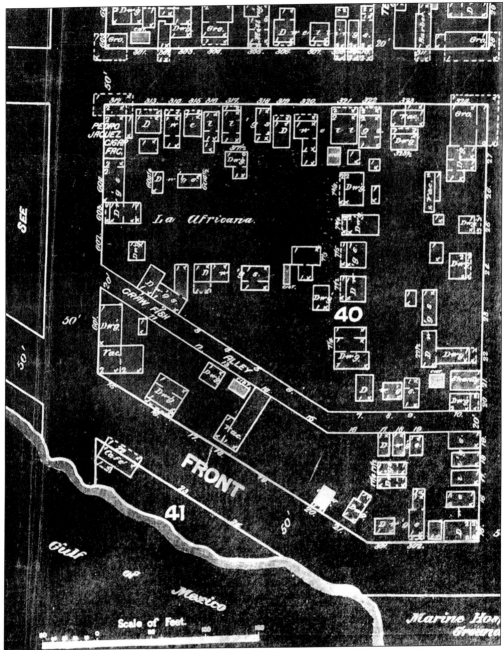

The region known as "La Africana," shown on the 1885 Sanborn Maps in Key West's Public Library, is the area where the true culture of black Key West was born. Freed Africans released from slave ships docked in Key West harbor or liberated from slavery after the Emancipation Proclamation was signed in 1865 made their new home in America in this community. Runaway slaves from southern states also found refuge in "La Africana," as did Cubans migrating from Cuba during the late 1840s to work in the growing cigar industry. Businesses thrived there and residents lived harmoniously in this close-knit community. White residents living in the vicinity were not intimidated by the presence of their colorful neighbors.

BLACK AMERICA SERIES

KEY WEST

Norma Jean Sawyer and LaVerne Wells-Bowie

ARCADIA
PUBLISHING

Copyright © 2002 by Norma Jean Sawyer and LaVerne Wells-Bowie
ISBN 978-0-7385-0684-5

Published by Arcadia Publishing
Charleston, South Carolina

Printed in the United States of America

Library of Congress Catalog Card Number: 2001087224

For all general information contact Arcadia Publishing at:
Telephone 843-853-2070
Fax 843-853-0044
E-mail sales@arcadiapublishing.com
For customer service and orders:
Toll-Free 1-888-313-2665

Visit us on the Internet at www.arcadiapublishing.com

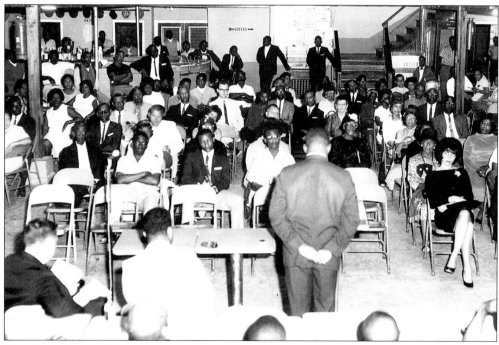

The descendants of the Africans, Cubans, white, and black Bahamians are still tied together culturally and politically in Key West. This is evidenced in this photograph of a meeting at the VFW/American Legion Hall located in the African-American community. Residents still work hard, maintain a sense of community, and collaborate with each other in developments that affect the quality of life in the Key West community.

CONTENTS

Acknowledgments 6

Introduction 7

1. Industry and Settlement Pattern 9
2. Architecture 31
3. Kinship and Community 45
4. Education 53
5. Civic and Social Organizations 71
6. Cultural Celebrations and Festivals 89
7. Entertainment 97
8. Legends and Landmarks 111

ACKNOWLEDGMENTS

I thank God for allowing me to be born on the beautiful tropical island of Key West and for moving my heart as a youth in Trinity Presbyterian Church to become a disciple of love, justice, and peace. I thank him for blessing me with all the talents needed to complete his missions and I thank my ancestors for their accomplishments and contributions in this community that made this book possible. I thank Althemese Barnes for encouraging me to write this book and LaVerne Wells-Bowie for agreeing to be my co-author and motivator although she is just as stressed-out, overworked, and underpaid as I am. To Mrs. Louise Whitehead, James Van Dyke, Donzel Leggett, Alfred Allen, Jose Planas, and others I called constantly for assistance with dates and names—thank you! To Mary and Edwar Weech; John Bruce Knowles Sr.; my sisters Rosemarie, Maxine, Magdelene, and Iva; my cousin Kirkalene Sewer; my church members Mrs. Eloise Smith, Roslyn Davis, Jim Stallings, and Lauriette Tynes; Gloria Dixon; Ernestine Curry; Joan Langley; librarian Tom Hambright; Martha Butler; Mrs. Fredeswinda Kenon; the Lofton B. Sands Estate; the late Mrs. Ruby Bain; and others who shared generously their time and precious photos for this book, thank you!

 I thank my sons Adrian, Ivan, and Kenneth for their love, moral support, and faith in my ability to get the book written, and I thank my praying circle partners Novella Washington, Lisamar Ramos, and Sharon Shorter for their healing prayers and spiritual encouragement. To my friends Brenda Miller, Rhoda Levenson, Mitch Major, and Lenora Banks who blessed me with financial assistance for trips to the Bahamas to do research for this work. I pray that this book will bless you all as well.

 I would like to dedicate this book to the memory of my mother Mamie L. Sawyer and Wright Langley, both of whom inspired me to research my familial history and to become a passionate keeper and expert storyteller of the African-Bahamian cultural history of Key West. I pray that this work will be a blessing and an inspiration to the black children of Key West and motivation for the community of traditional residents to keep our rich history and culture alive. Thanks to Baba Emese for making this all real for me.

INTRODUCTION

Alafia, "peace." In the name of our Afrikan ancestors in Key West, Florida, the Lofton B. Sands Afrikan Bahamian Museum and Resource Center presents pictures and stories of a Yoruba culture in Key West that has been ignored and almost forgotten.

In 1982, when Key West historian Sharon Wells authored *Forgotten Legacy, Blacks in Nineteenth Century Key West* and it was published by the Historic Key West Preservation Board, this important Yoruba culture was finally brought forth on paper. The book gave us an official, certified, statistical compilation of the ethnicity and immigration of blacks into Key West as early as the 1830s, and it offered information on settlement patterns; occupations; social, religious, and cultural heritage; and accomplishments despite the harsh environment in which the immigrants had to live and work. In her epilogue Ms. Wells stated, "Hopefully, this study has illumined one strand of Key West's multicultural ancestry and will open historical sources to future explorations." It did.

The late Mrs. Betty Townes Cox, a role model for many young women in Key West including the author, was an educator, an active member of Cornish Memorial A.M.E. Zion Church, an untiring civic and community leader, and a devoted daughter, wife, and mother. She wrote a brief non-pictorial article entitled "A Perspective on the Black Community in Key West" during the late 1990s as a contribution to a work entitled *The Florida Keys Environmental Story*, copyrighted in 1997 by the Monroe County Environmental Education Advisory Council. The book you hold compliments Mrs. Cox's written work and is an exploration and pictorial documentation of third and fourth generations of Key West blacks, bridging the history of blacks in the 19th century to those in the 20th century.

Twenty years later, joining other sisters and brothers who have vowed to document, preserve, and present our African-American stories to our children and the public, we present a more intimate look at the faces of "the fruits" of the Key West ancestors mentioned in Ms. Well's book. The included stories were contributed by many of the black community's elders and personal knowledge and experiences of author Norma Jean Sawyer. Native black residents still carry on some of the same traditions as their ancestors, worship the same way (although the numbers attending church have diminished), and occasionally still have funeral processions with marching fraternal organizations and bands. Some prominent families still carry on the businesses and occupations of their ancestors. The houses that Ms. Wells described architecturally are now shown with their black builders, and several of the secret men's societies (although somewhat

modified) she spoke about still exist and are shown in full splendor. We give the present generation of black children in Key West a stunning look at who they really are, where they came from, and what life was like for their parents and grandparents. We hope that they will be inspired to strive proudly, to achieve, and to continue the legacy that was left for them by their ancestors.

When Ms. Wells's *Forgotten Legacy* and this book are studied together, the uniqueness of the traditional black residents of Key West will be seen, revered, and appreciated. The beautiful photographs greet you with the love of a kind, hard working, melting pot of people who are proud, industrious, intelligent, loyal, compassionate, and sincere. Readers interested in Yoruba culture will be surprised to find (after reading both books) that Key West's early black community actually developed (unconsciously for the second generation of blacks) as a closely knit adaptation of a Yoruba village, with remnants still existing today.

We hope that this book will encourage further study and discussion of this "threatened" Key West culture and how it should and can be preserved. It is a rich culture that has been rooted in documented Africanisms that have survived quietly for over 170 years with settlement patterns that are still evident today. It is our prayers that this book will revive Key West's Afrikan cultural heritage; uplift those who need to discover, understand, accept, and be proud of their true ethnic identity; and encourage those in other African-American communities who are fighting to keep their birthright and continue the struggle to keep our stories and institutions alive.

Our efforts to carry on this Key West legacy will continue beyond this book through the second recognized Yoruba Afrikan Village in North America in the name of Esu, Shongo, Ogun, Obatala, Osun, Yemonja, Oya, Orumila, Adupe, Arikubabawa, Omoduduwa. It is located adjacent to the Lofton B. Sands Afrikan Bahamian Museum & Resource Center on US 1, and its address is 324 Truman Avenue, Key West, FL 33040, with Elder Yoruba Priest Baba Emese Mobolaji and The Old Key West Preservation Foundation leading the effort to present and preserve this historically significant way of survival for Afrikan people in America. This book is your personal invitation to come and experience our culture for yourself.

One

INDUSTRY AND SETTLEMENT PATTERN

After the Emancipation Proclamation was formally signed in 1863 the white establishment of the growing city of Key West welcomed African–Bahamian immigrants. Young and old came to escape the food shortage and hard times in the Bahamas and for new opportunities in America. While some became naturalized citizens, others did not. Many men and boys came as skilled laborers while women and girls worked as washerwomen, cooks, seamstresses, and midwives.

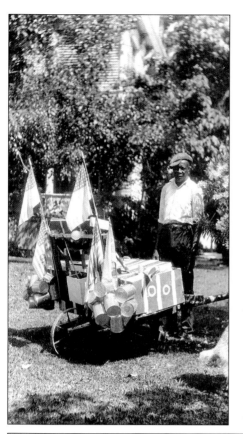

Randolph Cleare was a peddler in the early 1900s around his Key West neighborhood. He was said to have left from Harbour Island by boat in the Bahamian migration of 1891 and his family never heard from him again. He was very industrious and worked hard at selling his goods from his homemade cart. He also performed odd jobs around the neighborhood. (Courtesy of Wright Langley Collection.)

Jim Crow reared his ugly head in Key West during the 1920s when the Ku Klux Klan arrived intimidating Cubans, blacks, and whites. Relationships between some blacks and whites began to deteriorate but never to the point of extreme violence against each other. As a result, blacks had to have Assignment and Identification Cards to have access to certain work areas in Key West, especially around the waterfront.

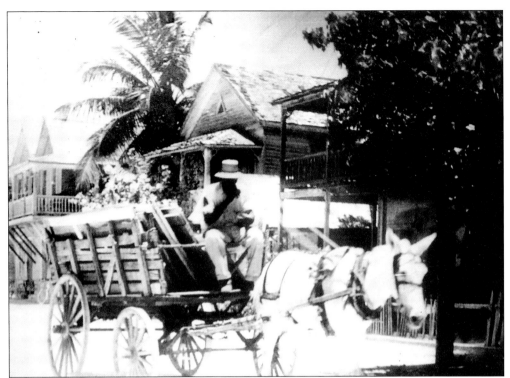

Horse and dray transportation was a thriving business in the early days. Mr. Eddie Matthews is seen above transporting materials with his dray. Houses were also deconstructed and moved to other locations by drays with metal wheels. Eventually, drays were replaced by motorized transportation in the mid-1900s and draymen were replaced by taxi cab drivers.

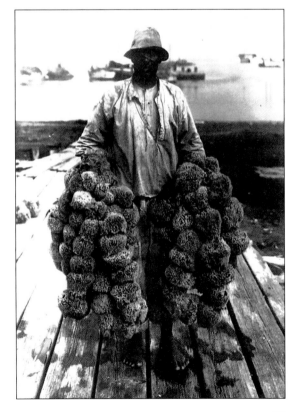

Mr. Sam Rogers was one of the black Bahamians who came to Key West to work in the booming sponge industry. Mr. Rogers, who was also known as the best coconut tree climber on the island, is shown here holding his catch for the day. (Courtesy of Wright Langley Collection.)

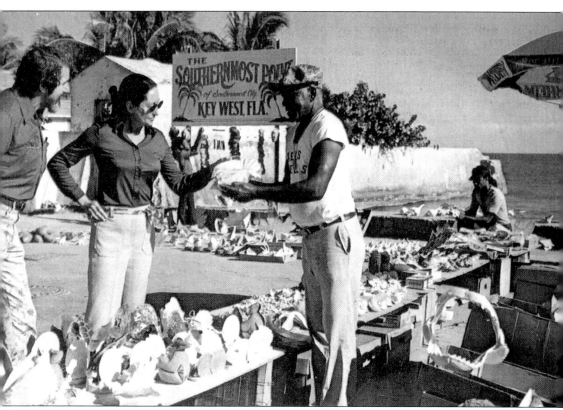

The selling of seashells and other island crafts at the Southernmost Point, which is located at the foot of Whitehead Street and the Atlantic Ocean in Key West, has been a family business since the late 1800s. Jim Kee, a Chinese immigrant and his wife Belan of Mantanzas, Cuba established and ran the business. In addition to the sale of shells at this site, it was also a community marketplace for selling fish, conch, and lobsters caught by local black fishermen. The Kee family had very colorful personalities, and they gave good directions and beautiful smiles to tourists who stopped by this particular spot. Fisherman Julian "Yankee" Kee, shown here holding the conch shell, was of the second generation of Kees to operate the spot. It still exists today and is now operated by the fourth and fifth generations of Kees. (Courtesy of Martha Butler.)

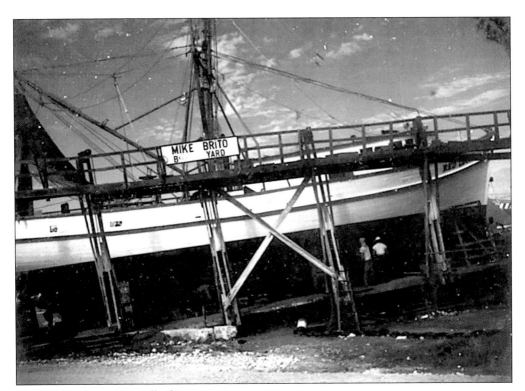

Black Bahamians, especially those from Harbor Island, were known for their first-rate shipbuilding. Sidney Evans was an excellent shipbuilder and carpenter. He built boats in his yard near the Key West cemetery in the neighborhood called the graveyard. In later years, boats were built and repaired at dry docks around the island.

Known as the graveyard neighborhood, this area between Truman Avenue and Angela Street bordered by Simonton and Frances Streets was the first permanent settlement for black and white Bahamian immigrants from Tarpum Bay, Eleuthera, Andros, and Nassau. It was also home for many Cuban immigrant families. Neighbors lived as families, and children were educated at an early age. The children were always chaperoned and disciplined by the elders, and taught to be very respectful.

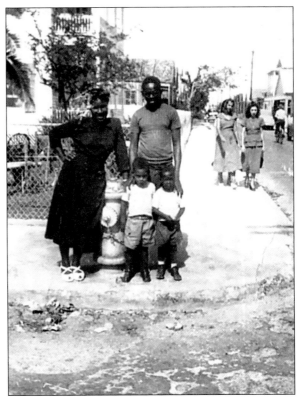

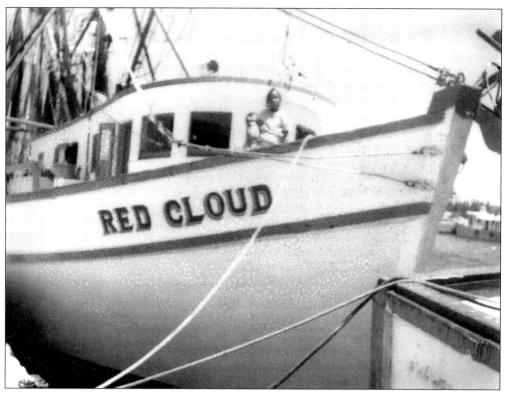

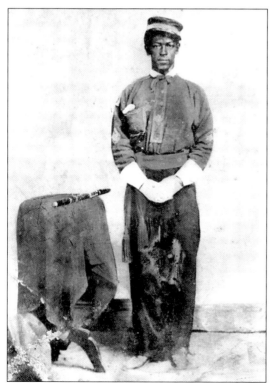

Fishing was a major industry for black and white Bahamian and Cuban men. During the Depression, the little fishermen fed many poor families on the island with fresh fish, lobsters, and conchs. Blacks also owned large boats like the *Red Cloud* seen above. Fishermen from as far away as North Carolina and Texas came to Key West to make their living catching shrimp and fish for large, commercial seafood companies.

Black bar pilots also steered boats in and out of Key West harbor during the late 1800s. Peter Welters Sr., shown in his militia uniform, followed in his father's footsteps and became a bar pilot. The family moved to Key West from St. Augustine, Florida, in the mid–1800s and became very instrumental in civic affairs, politics, and music. (Courtesy of Wright Langley Collection.)

Francisco C. Herrera Sr. was a cigar maker. Although Cubans fished in waters surrounding the Florida Keys in the early 1700s, during the early 1800s the majority of Cubans migrated from Cuba to work in the flourishing cigar industry. Francisco was among those who came to Key West for better opportunities. He was also the first Cuban in the black community to own an automobile.

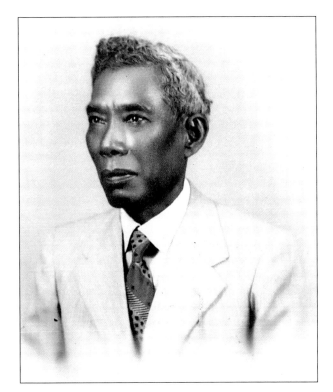

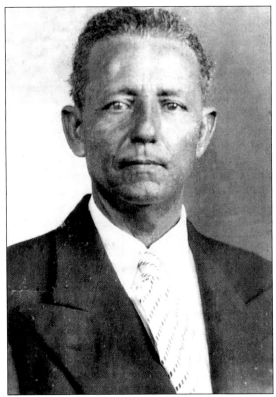

Eduardo Suarez came with his family from Mantanzas, Cuba. As a young boy, he had a great love for baseball. He became a cigar maker. Later he fell in love and married Frederica Pinder, a black Bahamian. Their marriage caused him to be banned from playing baseball in Key West, but the seven children they had together filled the void for the sport he loved.

Midwifery was Georgianna Sawyer's vocation until the late 1950s. Her brother, Chattam Saunders, a fisherman, came to Key West in 1878. He brought her over from Harbour Island as a young woman in the late 1880s. She married and became the mother of eight children and grandmother of author Norma Jean Sawyer. She delivered black and white babies and trained several young midwives before illness forced her to retire.

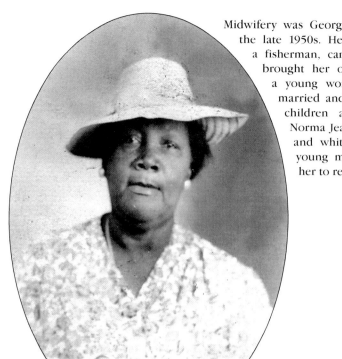

Augustina Herrera came to Key West from Guanabacoa, Cuba, with her husband in the late 1800s. She was a popular midwife among the Cuban population, and she delivered many babies as one of several midwives in the community. She was the mother of seven children born in Key West. Her daughter Fredeswinda Kennon, now 95, served the community as her parents did in many civic, church, and fraternal organizations.

Compliments of . . .

Modernistic Beauty Salon

Hair Stylists and Beauty Specialists

Mrs. Ida Sands, Prop.

313 Amelia

From the 1800s to the late 1970s, many women had home-based businesses, especially the hairdressers. There were at least six hairdressers in the African-American community licensed to do business between the 1920s and the early 1970s. Mrs. Hazel Seymour Saunders and her sister-in-law Mrs. Bloneva Quintana worked together. Mrs. Marguerite Welters, Mrs. Theodora Ward, and Mrs.Virginia Lennon Smith shared a shop. Mrs. Geneva Whalton was also a licensed cosmetologist who worked in a different shop.

Mrs. Ida Sands was both a popular licensed beautician and a practical nurse. Trained as a midwife by Mrs. Georgianna Sawyer, Mrs. Sands delivered babies in her own home, located at 319 Amelia Street. She is shown here in her cap and gown after graduating the 12th grade from Douglass High School night class. She was very active in Trinity Presbyterian Church, local civic organizations, and the Boy Scouts of America.

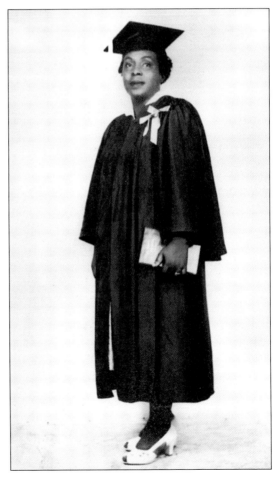

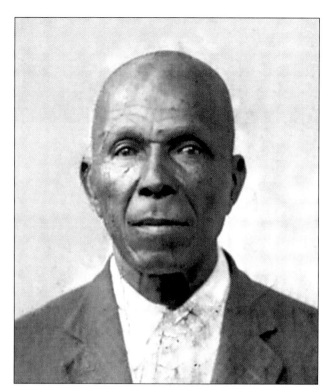

Born in Eleuthera, Samuel W. Sawyer (grandfather of author Norma Jean Sawyer), was the "backyard" barber for his sons and some of his neighbors during the early 1900s. Professional barbers like Theodore Navarro Sr., Willie Coker, and Mr. Forbes were licensed in the 1920s. Mariano "Coho" Perez and James Van Dyke followed these pioneers. Van Dyke was Robert Chappell's mentor after he graduated from school in the late 1950s.

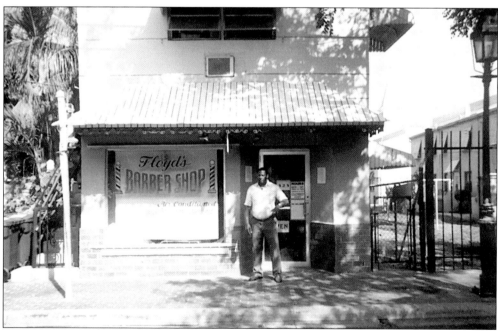

On Petronia Street there were two barbershops in the 1960s—Jeff's Barbershop near the Blue Moon Bar, and Floyd's Barbershop seen above with owner Floyd Sweeting Sr. standing in front. A Key West native, Floyd's family has been in business on Petronia Street for nearly 50 years. His son, Floyd Jr. and his brother Calvin Sweeting, both licensed barbers, work with him at times.

The African-American business corridor on Petronia Street was an exciting area, thriving with business from fishermen and military personnel until the navy base closed in 1974. Many residents transferred to other civil service jobs outside of Key West. This document, evidence of the hard times that beset the community, is a donation sheet acknowledging monetary gifts accepted by Eaker's Package Store to help with funeral expenses of someone in the community.

The "Mayor" of the 400 block of Petronia Street was Hilson "Eaker" Sweeting. He was a respected businessman, father, and a devoted member of St. Peters Episcopal Church. He was born in Key West to parents who had migrated from Bluff, Eleutheria, in the Bahamas. Eaker's Package Store, now managed and operated by his daughters, is the oldest black-owned business and still thrives at 415 Petronia Street.

> 8-17-79
> A Donation for the Breaverd Roberts, Famiely, From the people around Eaker's package Store.
>
> Eaker $5.00
> Nelson Thompson 5.00
> Louis Albury 5.00
> Emmerson pride 5.00
> Fread Bradley 2.00
> James Andrews 1.00
> Willard Mix 2.00
> Arthur Dorsett 5.00
> Shelly Asby 5.00
> Henry Gamble 2.00
>
> With Deepest Symphy, From the names above.

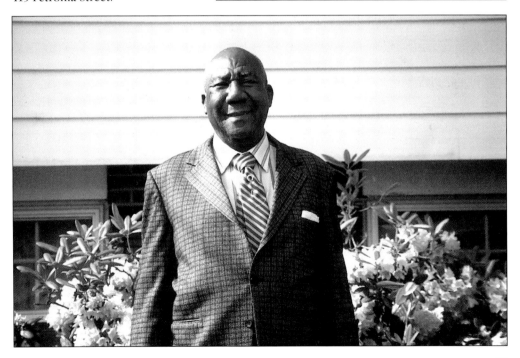

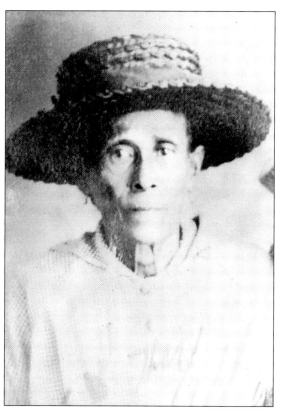

There were no clothing stores in Key West's black community in the 1800s, but there were many tailors and seamstresses. Mrs. Claudina Allen Turner, a seamstress, came to Key West with her brothers in the 1800s from Tarpon Bay, Eleuthera. The grandmother of community leader Charles Major Sr., Mrs. Turner lived near the graveyard and sewed at home for her children and many others in her neighborhood.

Several husband and wife teams carried on the sewing tradition from the late 1930s to late 1970s. Mrs. Georgianna Saunders Edwards, shown below, was married to tailor William "Cabill" Edwards Sr. A retired civil service seamstress, she had a business at home on Thomas Street. Cabill's shop was in downtown Key West. Seamstress Naomi Reddick Sawyer worked at home, while her husband Robert worked at his business on Whitehead Street.

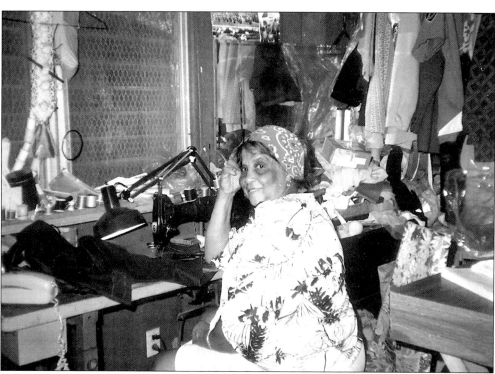

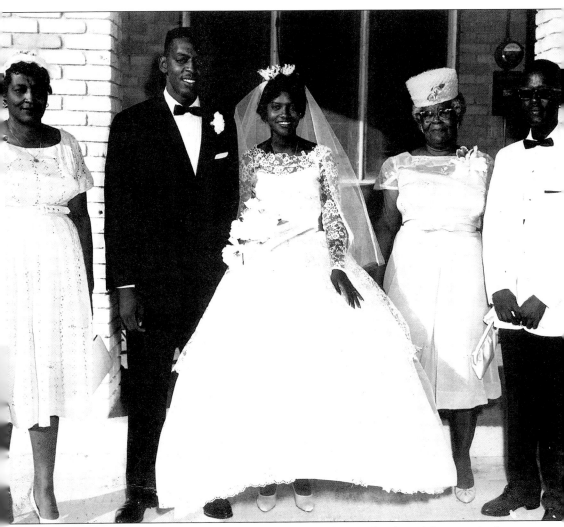

As an industry, sewing was a good trade that took care of many families. Often attached to pressing clubs in the early days, most of this work was done in the home. The proliferation of these businesses occurred during the early 1900s and during the WPA-era when the government provided sewing classes for women in the Key West community. After the Depression, segregated black Douglass High School offered sewing as part of the home economics course. For most seamstresses, all you had to do was show them a picture of what you wanted and they would get your measurements and make it for you. The beautiful wedding gown seen here was designed and sewn by Key West native Mrs. Vera Barnes, fourth from the left. This was a special family occasion for Mrs. Barnes because the bride, Sandra Barnes Ashe, is her granddaughter.

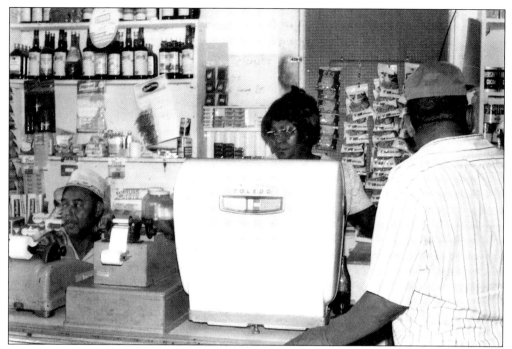

Small mom-and-pop businesses served African Americans during segregation in Key West. These establishments also served as community gathering and "watering holes" on the weekends and especially after a long, hard day at work. Located by the graveyard, John Bruce and Caroline Knowles, shown here, owned and operated a convenience store beside their home on Elizabeth Street.

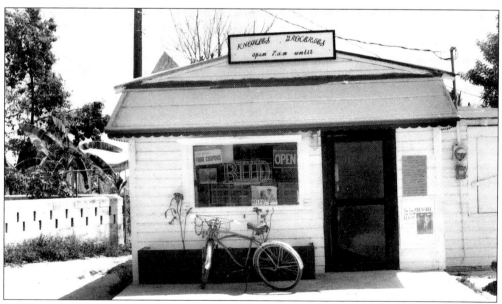

Parking was hardly an issue in earlier days when folks either walked or rode their bicycles to the neighborhood stores. Most of these stores were truly convenient because they were strategically located on neighborhood corners.

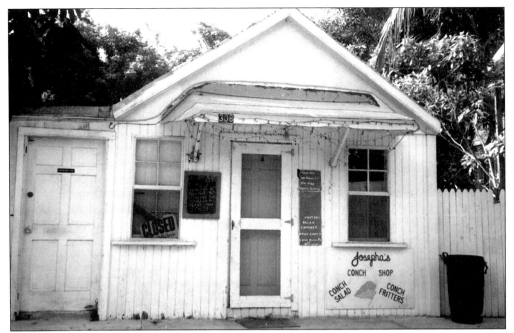

Across town, Josepha's, a popular, family-owned take-out stand and teenage hangout, was located in the family's front yard on Thomas Street. The shop sold the best conch fritters in Key West. As the business grew and stricter zoning laws took effect, the owners moved to the 308 Petronia Street store, seen here in the early 1970s, and renamed it "The Conch Shop." Still family-owned, it opens on Fridays and Saturdays.

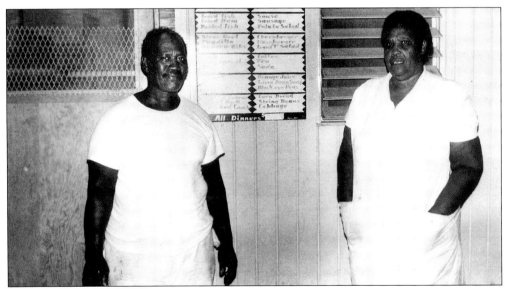

Standing in front of their Conch Shop menu, Josepha and Horace Mobley owned the favorite local restaurant and did all of the cooking for the restaurant, too. Real Bahamian foods like pigeon peas in rice, souse, conch, and freshly fried fish are deliciously prepared and served on the outside patio or for take-out. Even though retired, Horace occasionally goes in to help his daughters who now operate the restaurant.

The government was the largest employer in Key West for decades. Local men took care of their families as civil service employees in various capacities. Shown here is Clifton Lassiter, who was one of the few African-American waiters to work at the Navy Officer's Club on base at Fort Taylor. He could actually walk to work because the base is located adjacent to the African–American community.

In contrast to civil service employment, many of our men deserve the highest praise for their U.S. military service during World War I and II, the Korean War, the Vietnamese War, and Desert Storm. They are all a credit to their country, their families, and their communities. Men like Theodore Sands came back from World War II and became a respected teacher and music director at Douglass High School.

The son of Bahamian immigrants, Dwight Thompson was born in Key West and served his country proudly in the U.S. Air Force during the Korean War. He married a girl from Georgia and became the father of seven children, all of whom were born and raised in Key West.

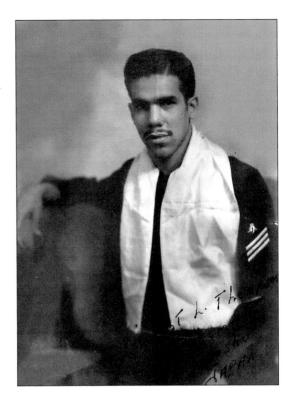

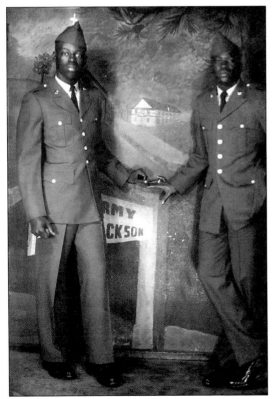

James Curry Jr., left, and James Singleton, right, were Key West High School classmates and basketball teammates. They both joined the U.S. Army and served valiantly in the Vietnam War during the 1970s.

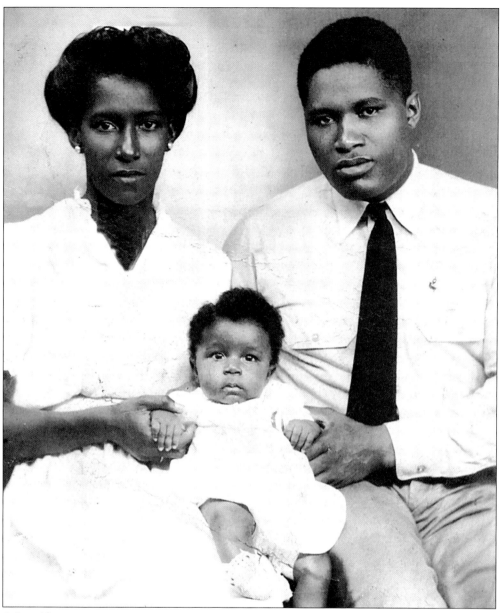

Other African-American men came to serve in the military here in Key West, stayed, and became a part of the community. They married local girls, had families, and made meaningful contributions to the community. Chester Conner, pictured here with his wife Doris Russell Conner and their son Leevon, came to Key West in the early 1940s and retired here as a chief petty officer (E–8) in 1961. He became a prominent civic leader in the community. As the NAACP chairman of the education committee, he fought boldly for desegregation of the Monroe County School District, which was accomplished in 1965. He served as first commander of American Legion Post 168 for 10 years and also held offices in the VFW Post 6021. He served as treasurer of Union Lodge #47 F & AM in Key West and served as Deputy Grand Master on the state level. He was the first African American to buy a home on Stock Island in the 1970s and was a devoted member of St. Peters Episcopal Church, having served on the vestry for over three decades.

Before being inducted into the U.S. Army, Jesse Sapp of Quincy, Florida, married Key West native Sylvia I. Farrington on December 19, 1942. He entered the service on January 28, 1943, and served in various locations around the world. He retired as a master sergeant and moved back to Key West in 1963. He and his wife established a small business selling vegetables and fruits and were active in civic and church organizations.

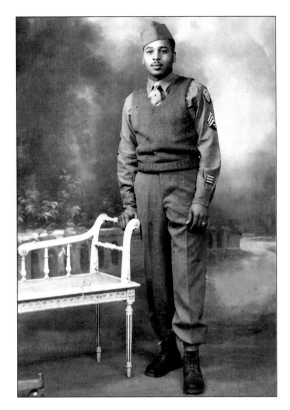

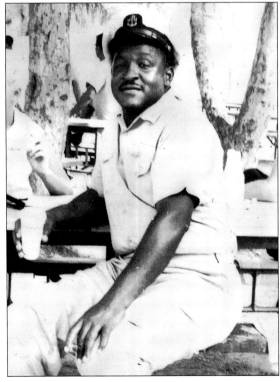

When Jim Eckford Stallings married Key Wester Leoncia C. Farrington, he was a chief in the U.S. Navy having served on the USS *Haddock*, a combat unit of Submarine Squad Ten that patrolled the Pacific area. Born in Starksville, Mississippi, Steward Chief Stallings retired from the navy on September 30, 1969. A member of Trinity Presbyterian Church, he invested in Evergreen Mortuary and holds memberships in the Silver Slipper Men's Club, the VFW and the American Legion.

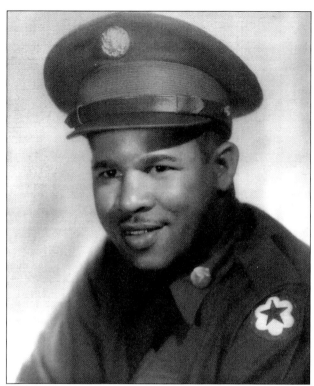

Theodore Carey served a short stint in the military and then returned to his Key West home and started a family. He carries on his family's legacy and is involved in the ministry. Like his grandfather and uncle before him, Rev. Theodore Carey continues to serve and care for his graveyard community through the ministry at Trinity Wesleyan Methodist Church.

Crispin Whitehead is shown below receiving a commendation upon his retirement as chef from the U.S. Naval Hospital. Born in Key West with Portuguese-African ancestry, Crispin never missed one day of work in his 47 years with the U.S. Civil Service. This is proof of the dedication Key West locals had for the military.

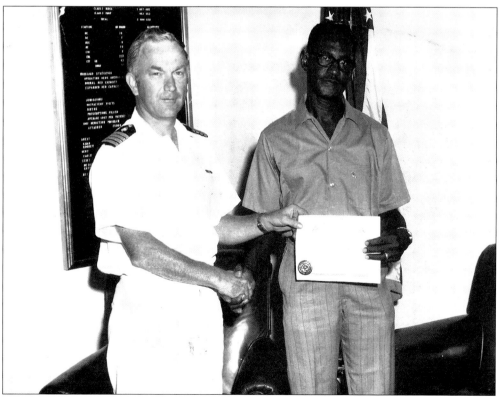

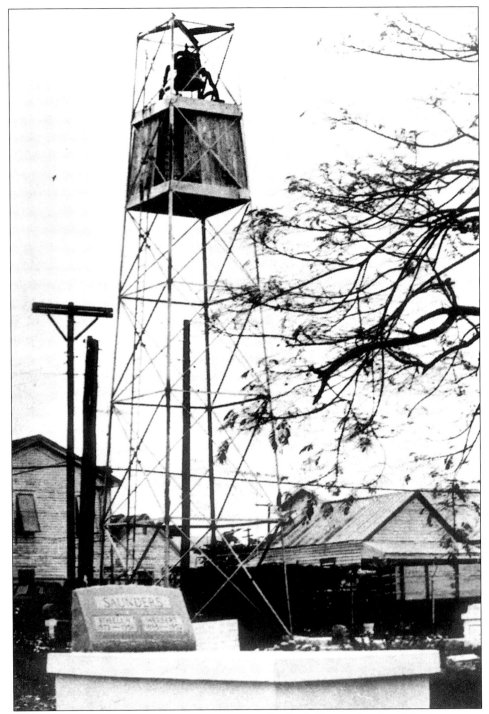

Located on the corner of Packer and Olivia Streets, the fire bell was a landmark in the graveyard community. Most of the working class white and black Bahamians settled in this area. When the fire bell rang it meant one of two things—a fire or that it was 9 p.m., the time for all children to be at home.

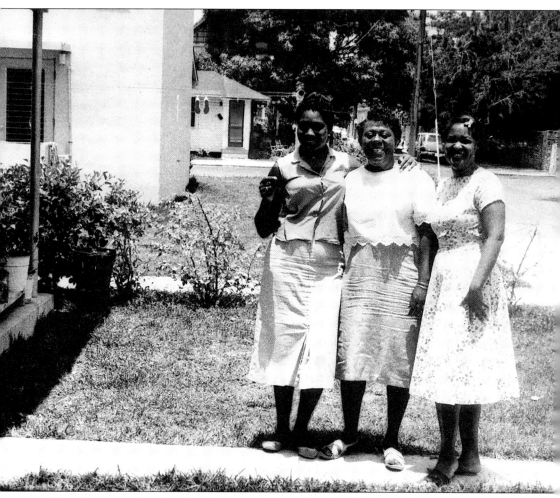

The above snapshot is of a "cross town" neighborhood (bordered by Simonton and Fort Streets from the south to the north and by Louisa and Southard Streets from east to west). The neighbors are standing in front of Key West public housing surrounded by private homes. The most popular of these homes is the residence of writer Ernest Hemingway, which is located behind the brick wall to the far right in the photo.

Two

Architecture

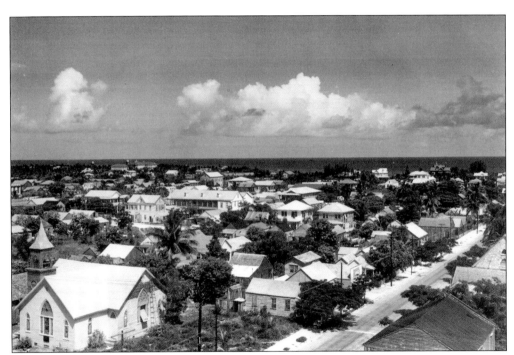

Bahamians were highly skilled tradesmen in carpentry, masonry, and plastering. In the late 1800s, nails were not used to build houses. The "mortise and tendon" method was applied. This method utilized a hand tool and wooden pegs inserted to keep the home together. This method allowed the homes to bend with the strong hurricane winds, instead of being torn apart by them. It also made it easier for the homes to be deconstructed and moved to new locations. This partial view of the black community taken from the Key West Lighthouse shows the many historical wooden structures built by blacks.

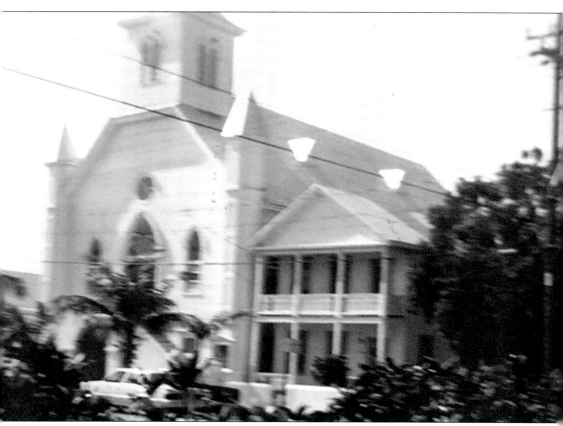

Cornish Memorial A.M.E. Zion Church, located at 704 Whitehead Street, was the first church in Key West built by Africans and Bahamians in 1865. Founded by Sandy Cornish, a runaway slave and prominent farmer and landowner on the island, this church is the only two-story church accessed by steps inside and outside of the building. It is also the oldest African Methodist Episcopal church in the state of Florida.

Milton Evans, born in Key West and trained by his shipbuilder father Sidney Evans, built many prominent structures in the area. In turn, he taught his sons, Harry and John, who followed in his footsteps. His great buildings are still visible today in Key West. Although he lost his sight in later years, he continued to serve as a dedicated church and community leader.

Milton Evans built Trinity Presbyterian Church in 1922. The church was first established in 1892 as Trinity English Wesleyan Methodist Church. The previous wooden structures were blown down by hurricanes in 1909 and 1910. This structure designed by Mr. Evans provided employment for 18 other skilled craftsmen and assistants, including his six and seven-year-old sons, John and Harry.

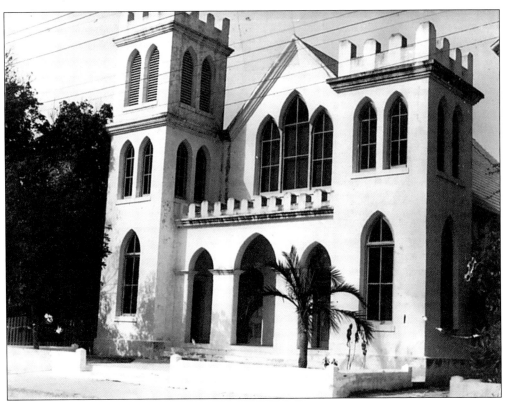

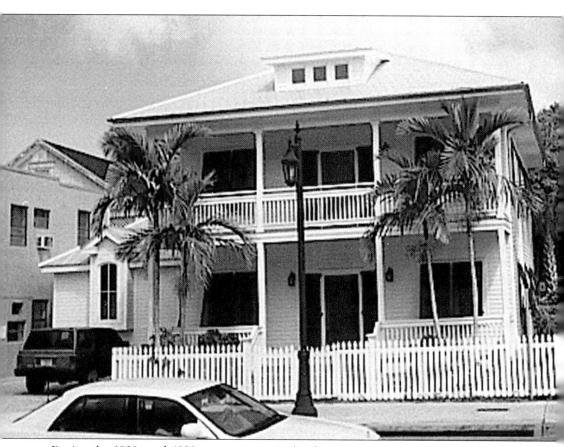

During the 1920s and 1930s, carpentry was the dominant trade for Bahamians in Key West. Most of the assistants learned the trades as they worked alongside more experienced builders. This beautiful, two-story home was built for Dr. Parramore, a popular physician in Key West. Soundly built, the home is located on what was called Jackson Square, which was the heart of the business community in those days. The home can still be found on the corner of Applerouth's Lane (formerly Smith Lane) and Whitehead Street and is now on the state of Florida's historic register.

Milton Evans built homes all around Key West like the one pictured above, which is located on the corner of United and William Streets. He constructed homes for both black and white residents of Key West.

This lovely home is located near the graveyard community on Petronia Street. Renovated in recent years, this shotgun-style home was built by Milton Evans in 1947 for businessman Hilson "Eaker" Sweeting and his family. The family still resides there.

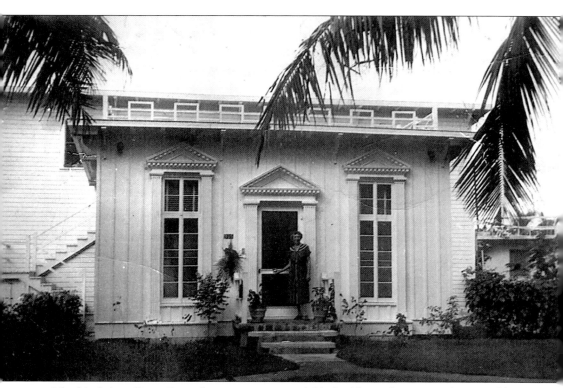

Like his father, Harry Evans became a commendable builder in his own rights. In addition to building homes as far up as Summerland Key and renovating the famed Audobon House on Whitehead Street in the 1960s, he also constructed this home on the corner of Von Phister and Grinnell Streets. He constructed the home for the Jackson family in 1949 and did the entire trimming by hand.

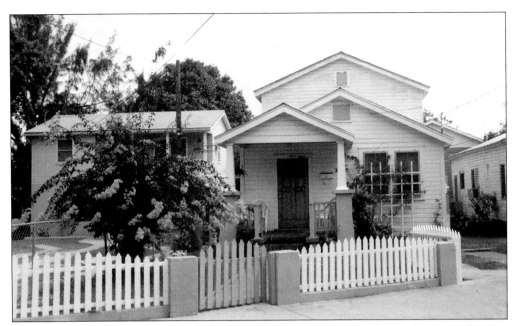

This home was built by local carpenter Alfred "Pepe" Allen and is also his residence. A Bahamian descendant, he helped to make homes for his family and friends. He also led the construction teams of the landmark VFW-American Legion Hall located on Emma Street in 1951, the Union No. 47 F & AM's building on the corner of Whitehead Street and Truman Avenue, and the rebuilding of St. James First Missionary Baptist Church.

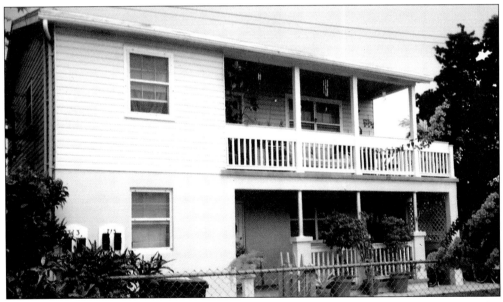

Bahamian carpenters believed in passing on trades to the young men in the community who were willing to learn. Alfred Allen owned this building, which was constructed under the supervision of his protégé Mitchell Major. Mitchell, also an accomplished builder, was given hands-on training in the trades of carpentry, plumbing, electrical wiring, masonry, and roofing by the graveyard Bahamian master craftsmen.

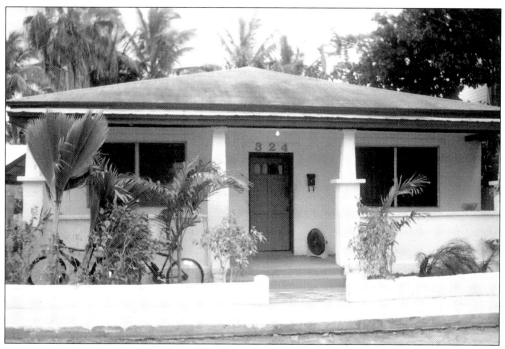

Jeremiah Albury built this four-bedroom brick home at 324 Julia Street in the 1940s for his sister Hester and her husband, business owner Arnold Roberts. It is one of the larger, single-story, shotgun-style houses in the black community.

Jeremiah Albury was born in the Bahamas and came to Key West as a young man. A mason by trade, he assisted in the building of several brick homes in Key West.

Thomas Major was the first black Bahamian hired as master plumbing inspector for the City of Key West. Born in Key West, Thomas also worked alongside his contemporaries as a carpenter and mason. He was Worshipful Master of Union Lodge No. 47 F & AM and was very involved in other civic and church organizations.

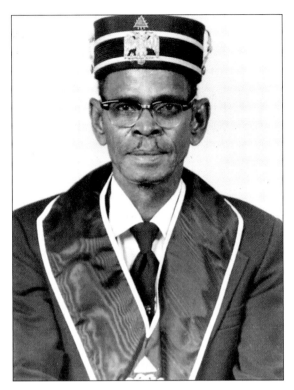

Thomas Major and friends constructed this concrete building located on the corner of Julia and Thomas Streets in 1943. Originally, Van Dyke's Barbershop and an ice cream parlor were located on the bottom floor. Thomas and his family lived in the upstairs unit. Today the renovated building houses four, one-bedroom apartments.

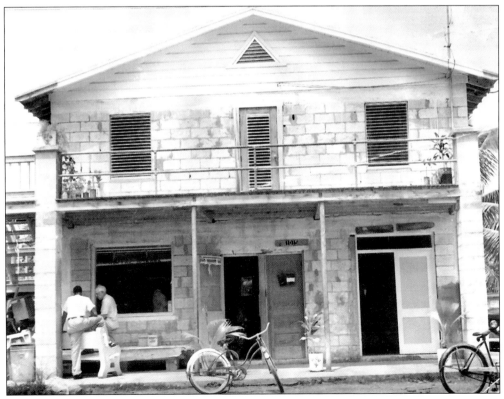

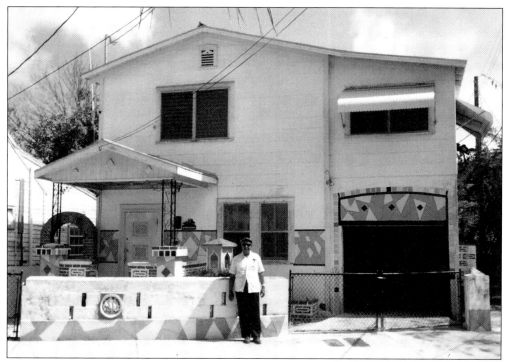

John Bruce Knowles Sr., a Bahamian descendent, is pictured standing in front of the home he built for his family in the late 1940s. He was trained as a draftsman, carpenter, and mason. He learned the crafts hands-on from older Bahamians while growing up in Miami and Key West. He loved tile work as evidenced by the creative art all around his Elizabeth Street home.

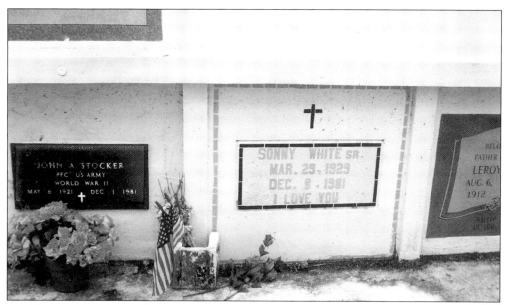

In addition to building and repairing homes, John Bruce Knowles Sr. also built burial vaults in the Key West Cemetery. Shown here is one of the many vaults designed and manufactured by him. The vault is decorated with his beautiful tile work.

Joseph Hannibal, one of four sons born to Shadrack Hannibal, was reared in Key West in the late 1890s. He was an accomplished builder and musician. With his three brothers Jimmy, Samuel, and Jeremiah, he was responsible for building many of the historic brick homes and churches in the black community. Joseph's grandfather was a skilled craftsman from Africa who escaped from a slave ship while passing near the Bahamas.

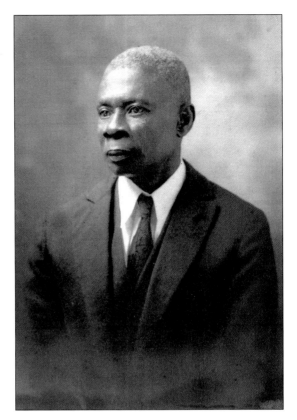

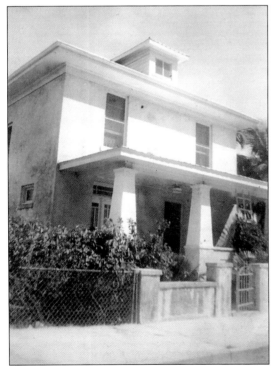

This two-story, five-bedroom, one-bath home was built in 1928 by Joseph Hannibal and his brother Jeremiah. Located at 324 Truman Avenue, it was built for black Bahamian Lofton B. Sands (Key West's first master electrician), his Cuban-born wife America, and their seven children. Today, it is the Lofton B. Sands African Bahamian Museum & Resource Center.

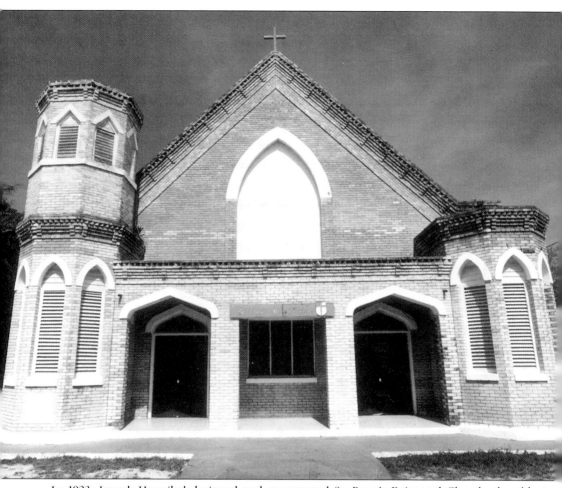

In 1923, Joseph Hannibal designed and constructed St. Peter's Episcopal Church, the oldest black Anglican church in the Diocese of South Florida. Shortly after he was born, his family moved back to the Bahamas and it was there that he developed his vocations. Joseph designed St. Peter's Episcopal church after his favorite cathedral in Nassau. His brothers, the parishioners, and the children of the church also helped with this labor of love. Parishioners brought in old bricks to be re-used for the foundation and the children were allowed to help make the grayish bricks from Joe's own special formula. (Contributed by Joseph Valdez, Church Historian).

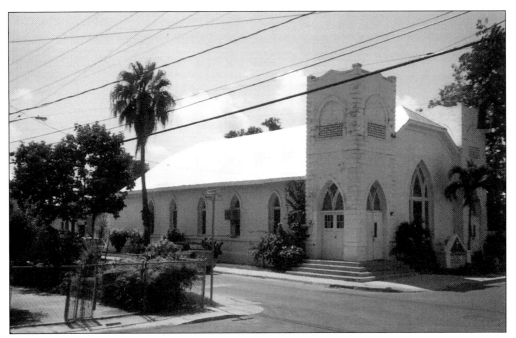

Bethel A.M.E. Church was constructed on the corner of Thomas Street and Truman Avenue in 1925 after vigilantes burned down the original church in 1921 at its Duval Street location. Henry Campbell, with assistance from the Hannibal brothers and other carpenters in the church, led the construction of the building.

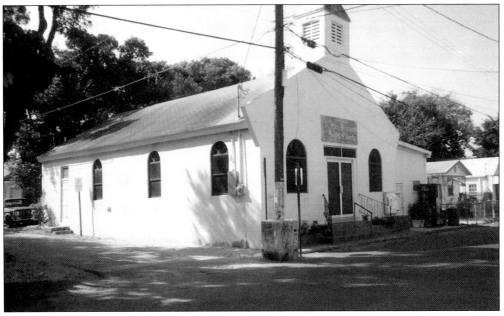

Local carpenters constructed the wooden St. James First Missionary Baptist Church located on the corner of Terry Lane and Olivia Street. The present brick structure was rebuilt around the wooden building in the 1950s. Alfred "Pepe" Allen supervised the team of church and community carpenters and masons.

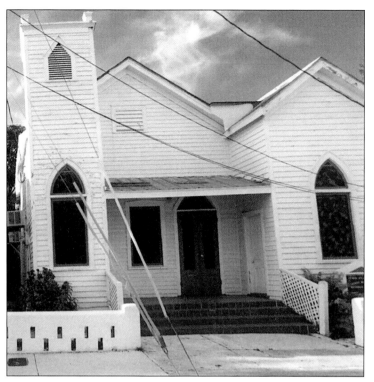

Several churches in the black community were originally family dwellings renovated to accommodate congregations. Founded by Rev. George W. Allen in the early 1930s, Trinity Wesleyan Methodist Church located at 624 Petronia Street was once a two-story family dwelling. Reverend Allen and church members Alfred "Pepe" Allen, John Bruce Knowles, Leonard Hepburn, Phillip Allen, and others, remodeled the building. It is affectionately called the "Allen Family Church."

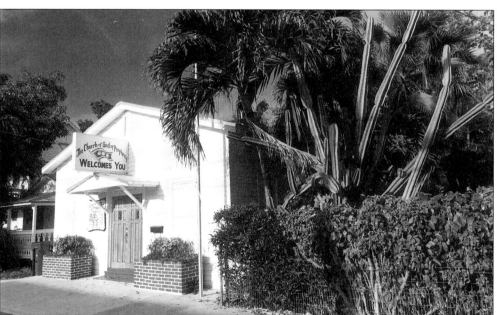

The Church of God of Prophecy was once a single-family dwelling and is approximately 800 square feet. Bahamian George Kemp and his protégé John Bruce Knowles remodeled the church in the late 1920s. Nestled among residential dwellings on Elizabeth Street, the church was called the "jumper church" by traditional natives and would be considered a "praise house" in other parts of rural black America where members met to "pray, shout, and sing praises to the Lord."

Three
KINSHIP AND COMMUNITY

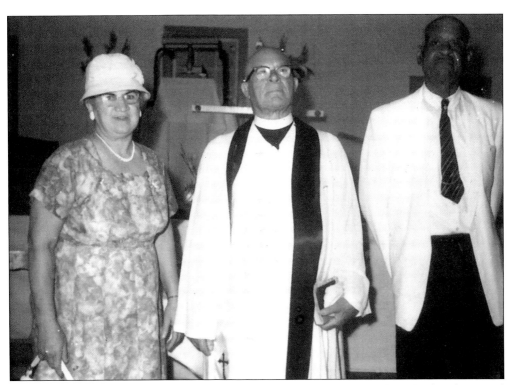

Rev. George W. Allen, shown in the center with his daughter Helen and her husband Leonard Carey, came from Tarpum Bay, Eleuthera, with his siblings in the late 1800s. The founder of Trinity Wesleyan Methodist Church, Reverend Allen was a respected community leader and patriarch of his clan. The Allen family is the largest African-American family of Bahamian descent in Key West and includes the Butlers and Careys by marriage.

The Ingraham sisters emigrated from Savannah Sound, Eleuthera, in the late 1800s. From left to right are Celestine (Farrington), Gladys (Evans), and Sarah. Celestine came to Key West at age 12 in servitude with a white family. Gladys came to the States via New York at age 19 to become a singer. She later traveled to Key West where she married and became a homemaker. Sarah settled in Miami and raised her family there.

Mr. and Mrs. David Bain were very active in the civic affairs of black Key West. David Bain, a Bahamian descendant, was a trumpet player. He showcased with several musical ensembles around Key West, namely the Honey Boys, during the 1930s and '40s. His wife, Wilhelmina, was a homemaker and a socialite. She was a leader in many civic organizations and active in her church.

Mr. and Mrs. Raymond Ambristol met and married in Key West in the late 1940s. Raymond came to Key West in the late 1930s as a young man from Green Turtle Key, Abaco. He became a U.S. citizen on January 11, 1954, at the age of 66. Irene was born in Key West to parents who emigrated from Savannah Sound, Eleuthera. Orphaned at a young age, she was reared by her mother's sister Georgianna Sawyer.

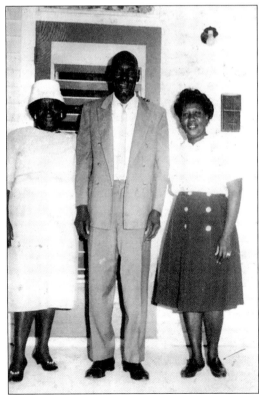

Mr. Burrows (center) came to Key West as a stowaway on a boat when he was eight. He left his native home of Long Island in the Bahamas in the late 1800s for a better life. After arriving in Key West, the community accepted him and he worked odd jobs around the neighborhood. His wife, Muriel Cleare, (left) was born in Key West and her parents came from Harbour Island, Bahamas. The two raised a family and their only daughter, Mary Burrows Weech, (right) studied to become a nurse. Mary trained as a midwife, raised her family in Key West, and like her parents became active in civic and church organizations.

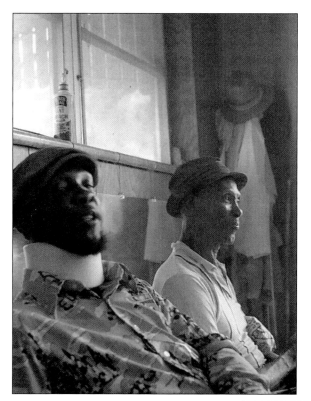

Otis Rahming, a native of Deep Creek, Andros Island, came to the States through Fort Pierce, Florida, when he was 17 years old. He later came to Key West, met and married Key West native Gloria Saunders, and they had 11 children. In addition to working in the navy yard, he was a sponge fisherman and property caretaker on Islamorada Key, Florida. He loved teaching the Bahamian Junkanoo music.

Mrs. Alice Whyms is seen here with her grandchildren. From left to right are Alexander Whyms, William Whyms Jr., Althea Sweeting (sitting), and Bertha Sweeting (in her lap). She came to Key West in the late 1890s from Andros Island to take care of her grandmother Madelina Pinder. Mrs. Pinder was one of the first midwives who came to Key West from Andros Island in the mid-1800s. Her family still resides in the home she purchased in 1871 at 823 Windsor Lane.

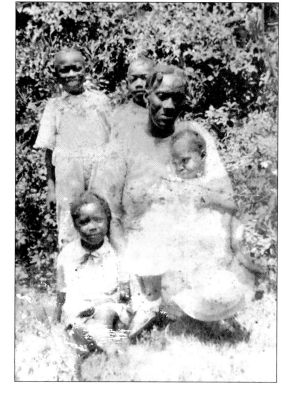

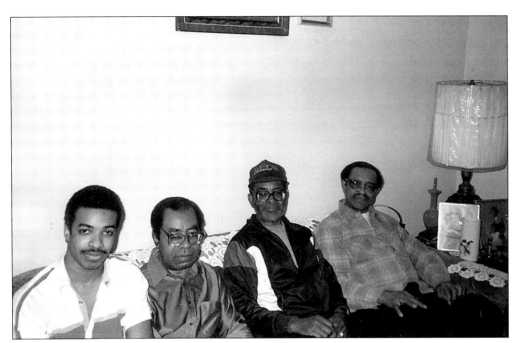

Famed author, professor, and Key West native Stephen Henderson (second from the left) is seated to the right of his son Alvin and to the left of his older brothers Antonio and James. James raised his family in Key West. The country of Uganda hailed Stephen as a great 20th-century writer and honored him with the release of a historic postal stamp embossed with his image. He died in 1998.

Peter Valdez is a Key West native. His father, Thomas Valdez, came to Key West as a merchant marine from Mexico in the early 1900s and married Claudina Falco, a Key West native. Peter's maternal grandmother, Julia, came from Cuba and married Emilio Falco, who hailed from Spain. Peter married Jerline Farrington of Bahamian descent and together they had nine children.

Alice Edden Leggett (left) and her daughter Olga Leggett Thompson were both born in Key West, Florida, and were devoted civic and church people. Alice's paternal grandfather, Frank Edden, came to Key West from Philadelphia in the 1800s. Her maternal great-grandparents owned half of Eneas Lane, which was named for her great-grandmother Frances Eneas. The family's homestead on Eneas Lane has been passed down through four generations as has the family's favorite recipes. Alice's grandmother Laura Eneas cooked meals for the black pullman porters who stopped here on Flagler's railroad during the early 1900s. (Courtesy of Donzel S. Leggett.)

Mrs. Ida Sawyer Jones was separated from her African family during the British slave trading days. She was brought to Key West from Cat Island, Bahamas, in the late 1890s. She came in servitude as a young girl and worked for her white family as a housemaid and later as a nanny for their children. Her intimate relationship with a white Bahamian produced two offspring, Maggie Parks and Julia Parks Rios.

Children of mixed parentage help to make the rich heritage of black Key West, all acknowledged by their parents and the community whether they are white, African, Bahamian, or Cuban. The descendants of Mrs. Jones, all born in Key West, are pictured here. From left to right are her grandson, Rupert Rios; her daughter, Julia Parks Rios; her great-grandson, Edwar Weech; and her granddaughter, Eleanor Rios Weech.

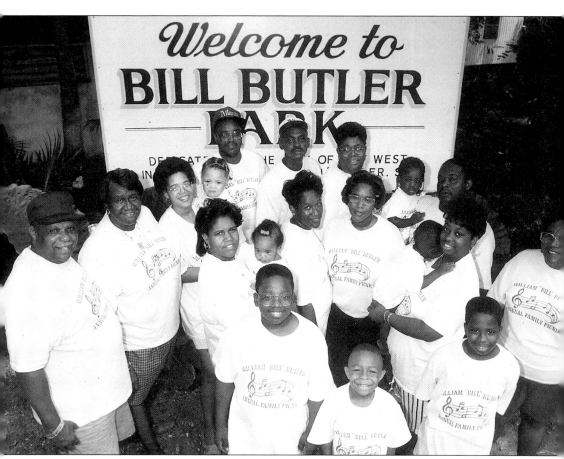

Family reunions are a time for relatives to gather, remember the contributions of their ancestors, and celebrate the legacies they left. The descendants of Bill and Floriette Edwards Butler meet in the park named for Bill Butler behind their family homestead in the graveyard community. Bill and Floriette were born in Key West and their grandparents came from the Bahamas in the late 1890s. The Butlers are a very musical family and all of Bill's siblings were taught music by their father. His daughter Barbara Butler Dickerson chose to remain in Key West to raise her family in the family homestead. She still worships and sings in the choir at Trinity Wesleyan Methodist Church. She and her sister Shirley Saunders are involved in civic and community organizations in their respective communities. (Courtesy of Mrs. Barbara Butler Dickerson.)

Four

EDUCATION

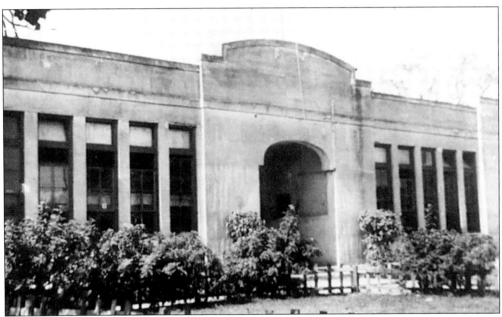

The black people of Key West, like blacks throughout the Bahamas and America, believed strongly in educating their children so that they might have a better quality of life. Before the construction of school buildings, children were taught in the homes of schoolteachers who ventured to Key West. The Freedmen's Aide Society built a school in Key West next to Newman United Methodist Church. Shown here is Douglass Jr. High School, which was built on Thomas Street, between Angela and Southard Streets, in the early 1920s on land donated to the Monroe County School Board by the black community. Classes for grades six through eight were taught here. After the outbreak of World War II, the navy needed to expand their military base, which was adjacent to the black community. For less than its market value, the navy purchased the surrounding land and buildings from the community, displacing many families. The building became the navy laundry, and many of the residents were hired to work there.

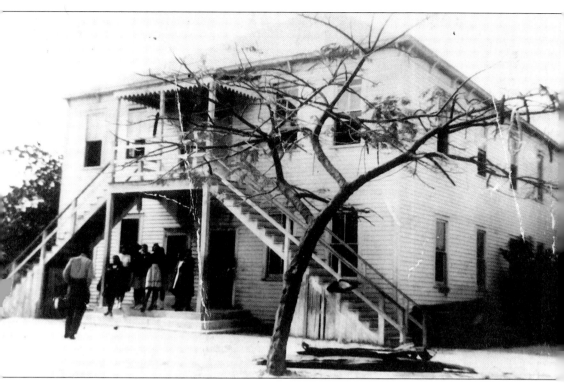

The first public schools built for black children in Key West were named for the famous orator and activist Frederick Douglass who visited his friend Sandy Cornish in Key West during the late 1890s. Douglass High School, which was built in the early 1920s, is seen above. Located on Emma Street between Angela and Southard Streets, it sat directly behind Douglass Jr. High School. This is the only known photograph of the two-story wooden structure that Bahamian carpenters built. There were eight students in the first graduating class of 1929. Before this building was erected, students who desired an education beyond the eighth grade were sent to Miami, Daytona, or St. Augustine, Florida. The school had a woodworking shop, an auditorium for assemblies, and a school bell that was situated under the stairs near the entrance of the building. This Douglass High School was demolished when the navy expanded the military base during World War II. Famed Key Westers Stephen Henderson, Frank Pinder, and Theodore "Fats" Navarro all graduated from Douglass High.

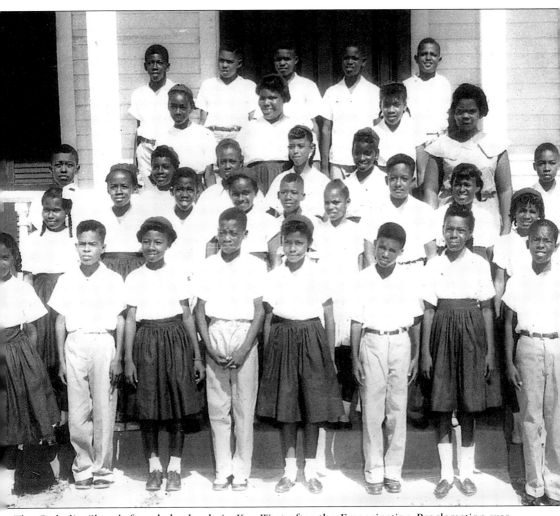

The Catholic Church founded schools in Key West after the Emancipation Proclamation was signed in 1863 to help educate black children. Black and white children were taught separately and initially, girls were taught separately from boys. Black boys went to St. Joseph's and the girls went to St. Francis Xavier. Reading was taught by phonics and most students were grateful for the strict discipline from the sisters. Among other classes, the school taught music and drama. Programs and graduations for the black students were held at St. Joseph's Hall, which was built on property owned by the Catholic Church at the corner of Angela and Thomas Streets in the black community. In the late 1950s, St. Joseph's was eliminated and boys and girls were taught together in classes at St. Francis Xavier. This picture was taken in front of St. Francis Xavier several years before it was closed in the mid-1960s and replaced by the integrated St. Mary's Star of the Sea Catholic High School.

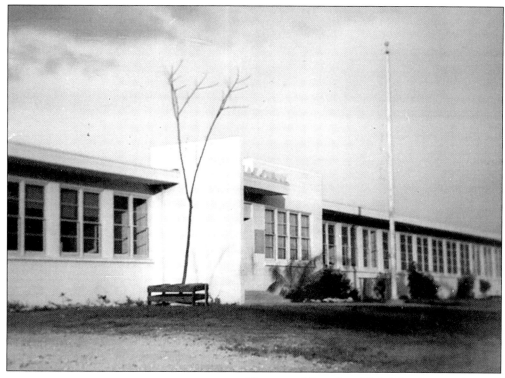

The second Douglass High School, seen above, was built in 1946. This structure replaced a wooden high school that was demolished during World War II. The brick building, situated between Olivia and Petronia Streets and bordered by Emma and Fort Streets, housed classes for grades one through twelve. It was the "Home of the Tigers" and had both an excellent sports and music program, bringing statewide acclaim for the school.

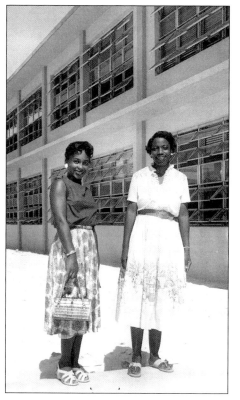

This new addition to Douglass High School was built in the early 1960s to accommodate the growing junior high school population. Teacher Barbara Curry (left) and her unidentified co-worker were proud of the new addition that allowed more space for the science and chemistry labs and the history department.

Wood Shop at Douglass was an important class as it prepared young men and women for a trade that is always in demand. Learning the trade also prepared young men not going to college for an occupation that would help them take care of a family. Seen here with their class project, from left to right, are Orion Hepburn, Glenwood Lopez, and Benjamin Gardner.

Oral hygiene was a part of the home economics class at Douglass. Below, the visiting dentist came to the school to give check-ups and to demonstrate proper cleaning procedures to the girls.

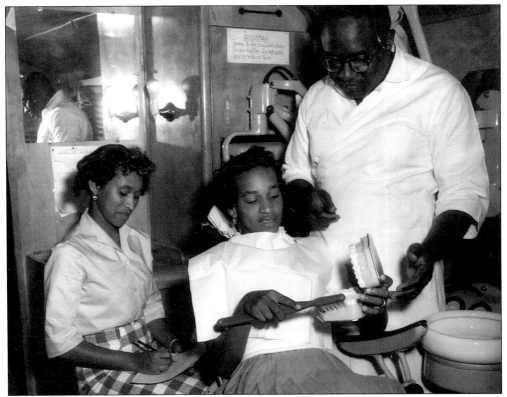

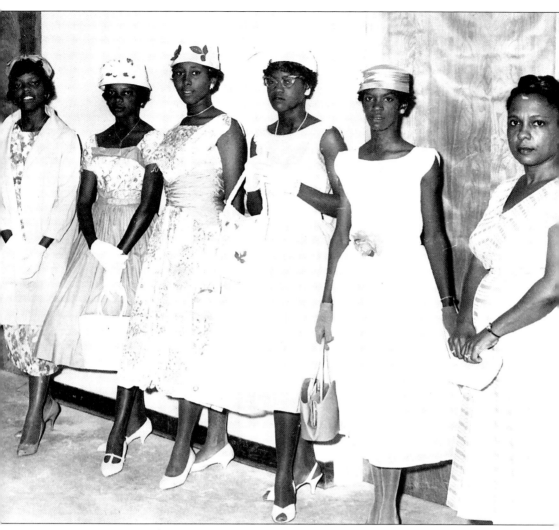

Mrs. Carrie Devon (far right) was the home economics teacher at Douglass High School. Mrs. Devon's job was to prepare the young girls for roles of wives and mothers. Between the late 1920s and 1950s, most girls were discouraged from seeking careers outside of the home. Here, she poses with her girls whom she has taught to dress and stand properly when they are out and about in public on special occasions. In addition to etiquette, Mrs. Devon taught sewing, first aide, and personal hygiene. Cooking classes were the most enjoyable, especially on Fridays, as student groups would have sandwich sales to raise money for special class projects or trips out of town. The sales also provided lessons in taking food orders, handling money, and customer relations, not to mention the delightful aroma of fried chicken and pork chops that filled the school halls at lunchtime.

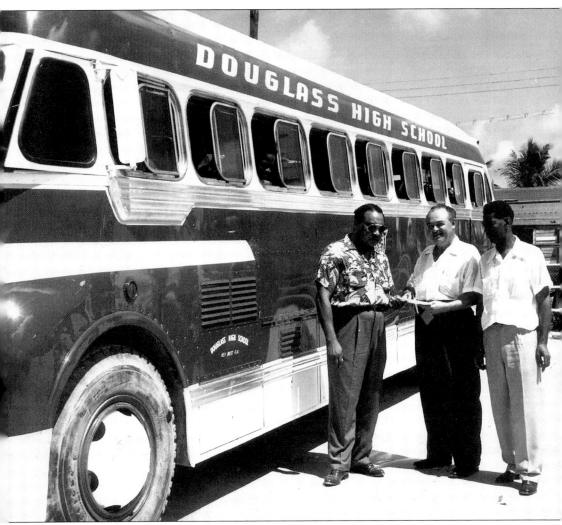

The Douglass High School Tigers traveled all over Florida in this green and white school bus. The football team, the basketball team, and the marching band all traveled from time to time to compete against other schools within the state. In addition to out of town trips, the bus was also used for local field trips for elementary and junior high school students. The trips were always fun for students and the chaperones. Pictured from left to right are Principal Seabury, P.E. Coach Eugene Dolphus, and teacher Alfred Saunders as they prepare to take students on a bus trip.

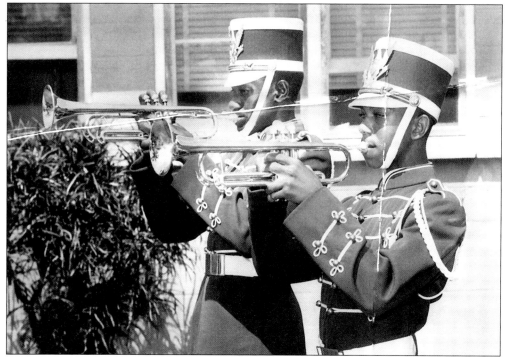

John Lord (left) and Errol Hanna, both born in Key West, were members of the Douglass High School Marching Band. Here, the pair prepares for their show-stopping performance with the band. The Marching Tigers surpassed all other high school bands in the area. The band was a state champion and many students desired to join.

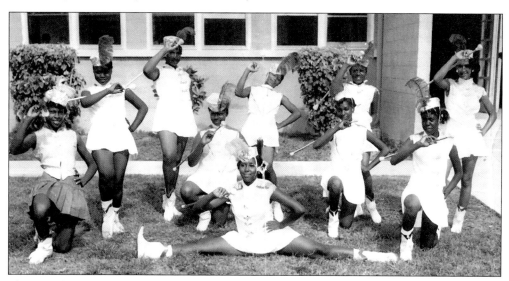

The Douglass High School Majorettes were another popular group with parade-goers. From left to right are (front row) Marie Ashe, Pearl Mae Lee, Aloma Lopez, Alice Williams, Rofelia Pla, Elena Symonette; (middle row) Carolyn Bowe, Jeanette Manual, and Gloria Singleton; and in the (center) Doreen Johnson. These high-stepping, young ladies escorted their Marching Tigers through many parades, in Key West and Miami, Florida.

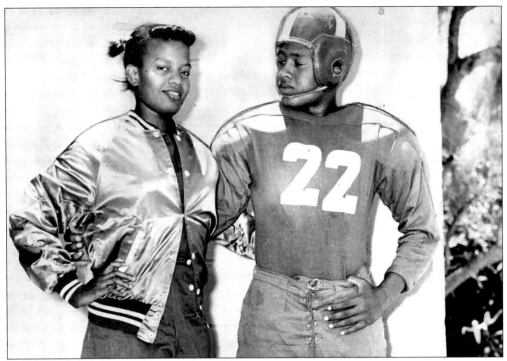

During football season, Douglass High competed well with their "Fighting Tigers" football team. The football team played squads as close as Goulds, Homestead, Miami, and as far away as Fort Lauderdale, Florida. Cheerleaders accompanied the team sometimes to give moral support, especially when the opposing team was tough. Shown here are cheerleader captain Izette Scott and varsity football team captain Theodore Suarez.

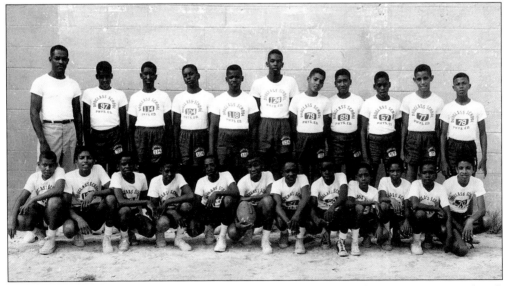

Douglass High School had grades one through twelve. The basketball program started with junior high school. Shown here are members of the junior high basketball team. Sports kept the young boys physically fit and disciplined.

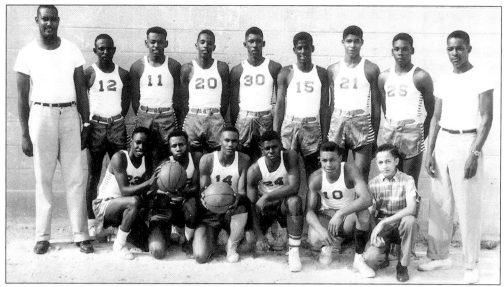

Half the size of the junior high basketball team, the Douglass High School junior varsity team shown here was just as energetic and talented as their younger counterparts.

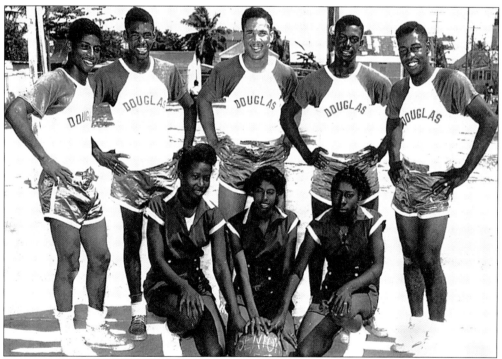

At Douglass High School, girls also participated in basketball. The Lady Tigers were a first-rate team, winning Florida's first state conference championship title in the 1950s. Some of the members of Lady Tigers team appear with some boys from their basketball team. From left to right, they are (kneeling) Shirley Roberts, Pauline Edwards, and Alice Winters; (standing) Alfred Saunders Jr., Hilton Williams, Kenneth Carey, Anthony Sawyer, and Charles Clarke. All were members of the class of 1953.

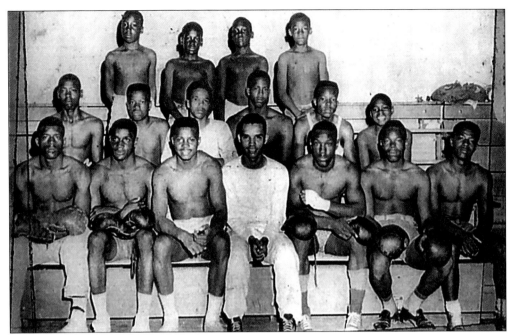

Individuals from the community also got involved with educating and training the youth in athletic disciplines that taught strength, endurance, and agility. Angel "Lefty" Betancourt (center of first row) came to Key West in 1957 with the navy and never left. In 1958, the experienced Golden Glove champion began evening classes at the Douglass High School gym for youth ages 12 to 23. This was one of his classes.

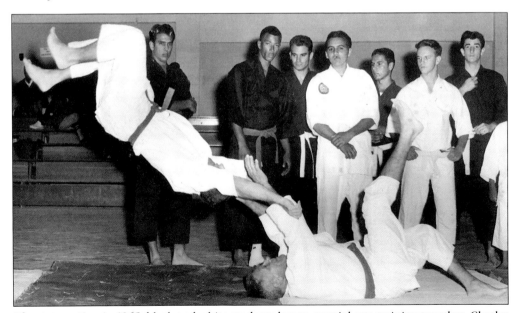

After integration in 1965, black and white students began martial arts training together. Charles Major Jr. (standing second from left) watches as he learns techniques that he would teach to children in his neighborhood. He inspired many black youth to learn and participate in the martial arts.

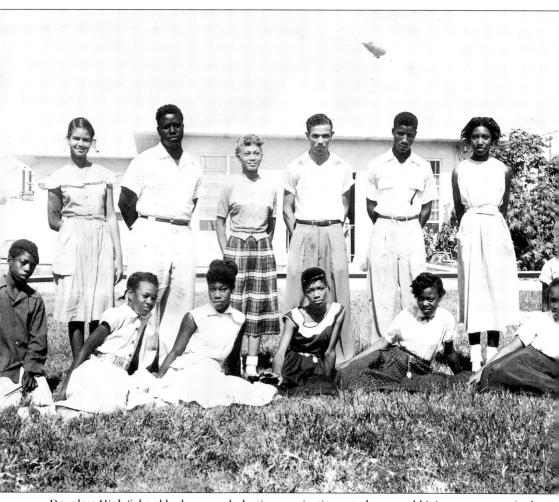

Douglass High School had many scholastic organizations students could join as extra-curricular activities. Students had to have an A or B average to qualify and membership in any of them brought prestige and respect. Shown here are members of the National Honor Society representing grades 9–12. Many of them have become prominent civic–minded professionals. Phyllis Allen (sitting on the far right of the front row) is the youngest of the group. After graduating from high school in 1959, she finished her college education and returned to Key West where she eventually became assistant superintendent of the Monroe County School System and assistant director of the Pace School for Girls. Virginia Burgohy (standing on the far left on the back row) also graduated in 1959 and is now Dr. Virginia Irving. Her specialty is historic and cultural program development. She also specializes in the development of curricula for children at risk.

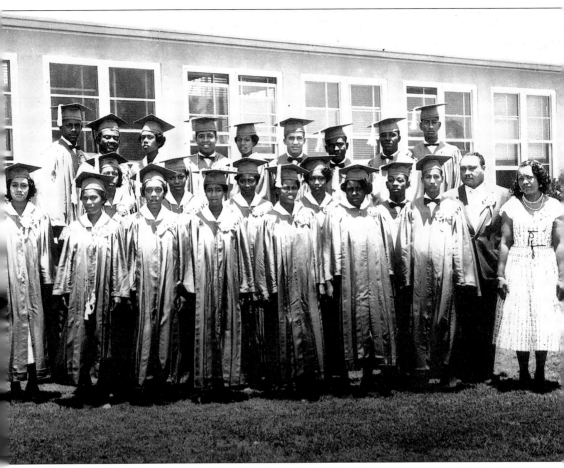

The 1950s Douglass High School graduating class poses with their class sponsor, Mrs. Isabel Sands (last on the front row) and Principal Seabury. Graduation was a special time at Douglass that brought the anticipation of report cards, class parties, and commencement ceremonies. Douglass High School was the pride of the neighborhood because the faculty and staff truly cared for the students, and the feelings were reciprocated.

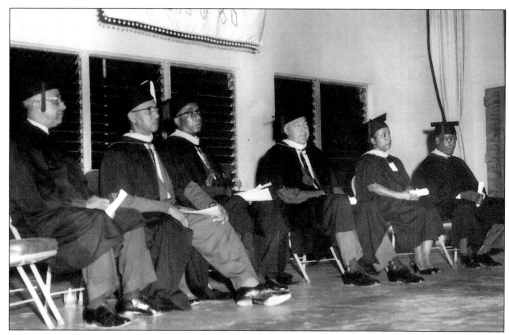

Before the gymnasium was built, graduation ceremonies were held outdoors on the Douglass High School grounds. County officials and faculty sat on platforms on the outside. In 1946, a stage was built in the new gym. Now officials are able to sit on the large stage during graduation to participate in the ceremonies. Seated third from the left is Principal Alfred Sands, Superintendent Horace O'Bryant, and teachers Carrie Minor Devon, and Otha Cox.

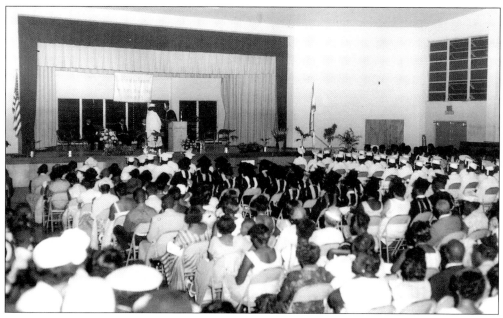

The black community of Key West was very supportive of Douglass High School. Here is a typical graduation ceremony at Douglass High School. This picture shows a commencement ceremony.

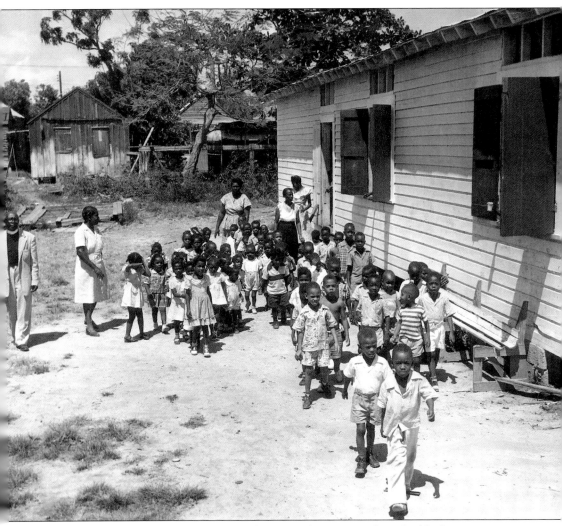

The church was also very involved with the education of young minds in the black community. This photograph shows a kindergarten class operated by St. Peters Episcopal Church located next door to the sanctuary. Affectionately called "Miss Nora's Kindergarten," many of Key West's children began their education there at age four. The priest would check on the class from time to time and Miss Nora always had at least three aides to help her. Under Miss Nora's tutelage, by age five, each child could memorize prayers, nursery rhymes and songs; count from 1 to 100; and recite the ABCs, the days of the week, and the months of the year. They also learned the most important lessons of all—how to obey and be respectful to elders around them.

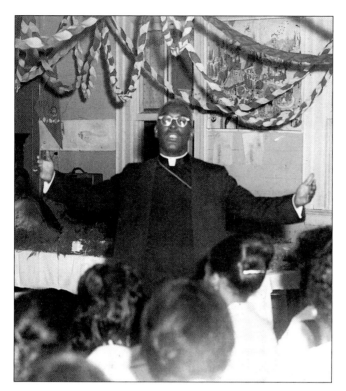

Father John Henry Reese, one of St. Peter's toughest educators, conducted a summer school program for kids aged 12 to 18 in the church's parish hall. This curriculum was not for the fainthearted, as Father Reese was very strict. This course was designed to help the young people stay ahead in school academically and to teach them good study habits and wholesome competition.

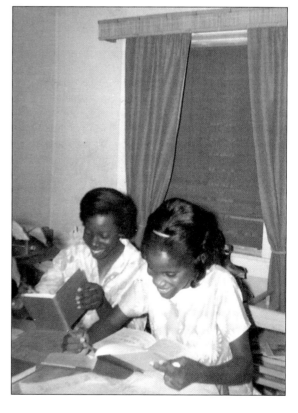

Learning at Father Reese's summer school was a lot of fun. Classmates Barbara Harley (left) and Norene Fisher (right) prepare for a class competition. The school was divided into two groups, Sacred Heart (red) and Corpus Christi (blue), and there were always scholastic and athletic contests between the groups. Students took their study projects home, and people in the community were always invited to their programs.

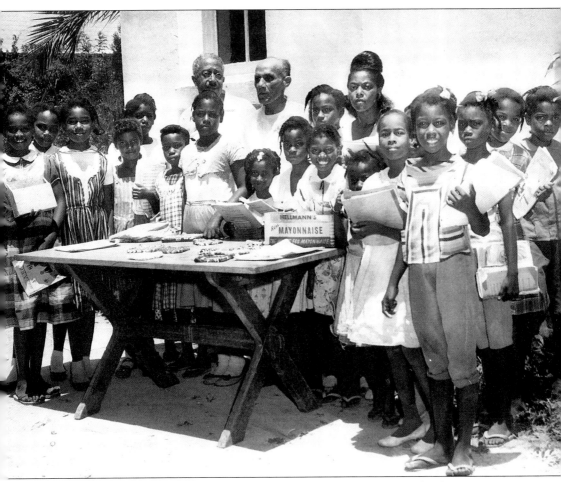

Trinity Presbyterian Church held bible school every year for the children of the black community. Rev. Clarence Richmond (back row, left) and Milton Evans (back row, center) were in charge of developing the program for the school. One of the largest in the community, the program hosted children from age 4 to 18 to learn the commandments, the golden rule, bible verses, and prayers; make arts and crafts; and attend field trips.

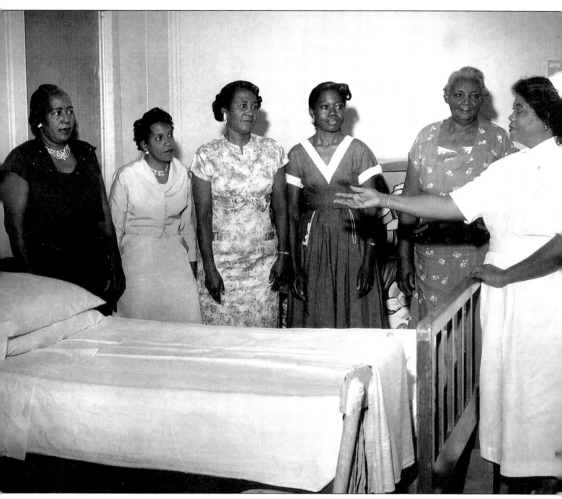

Adult Education classes were offered in the black community for those desiring to increase their earning potential. During the 1920s, Douglass High School only had classes up to the tenth grade. Graduates wanting to continue their education would have to leave the area. This was not an option for many, but in later years they were able to attend evening classes to learn sewing and typing and enroll in nurses aide and ward–clerk training programs. There were many opportunities for employment as a nurse's aide during the 1960s at Monroe General Hospital or Depoo Hospital. Many women in the black community took advantage of the training and most of them were hired to care for homebound patients. Standing second from the left is Wilhelmina Marerro. Her grandmother was a midwife from Cuba and her mother was also in nursing. It was no surprise to anyone when she took up nursing.

Five
CIVIC AND SOCIAL ORGANIZATIONS

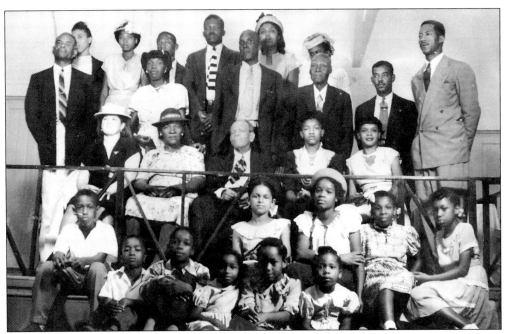

In most black communities, the church is the foundation for civic and social awareness. There, you are taught to love the Creator, respect nature, and love your neighbors as yourself. These tenets are the basis of the civic and social organizations within the black community of Key West. This photo, taken in the early 1950s, shows of an early congregation of Trinity Wesleyan Methodist Church, also known as "Reverend Allen's Church." All of the adults in this photo were involved with at least one of the many clubs within the church or community. They were role models for the young children to emulate.

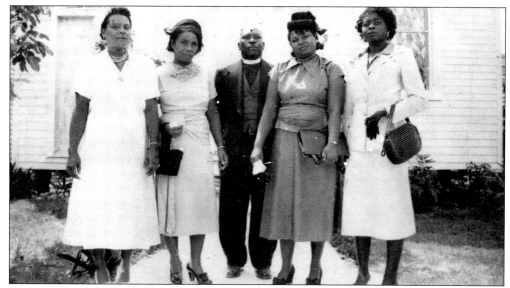

Members of the McKinney family pictured here carried on the legacy of Zion Primitive Baptist Church, which was established by early Africans who settled in Key West during the early 1800s. The church had benevolent societies that served their congregation and they preserved some of the social norms of their African ancestors. From left to right are Lola McKinney, Effie McKinney Lassiter, the Reverend McKinney, Georgia McKinney, and Eva Mae Lassiter.

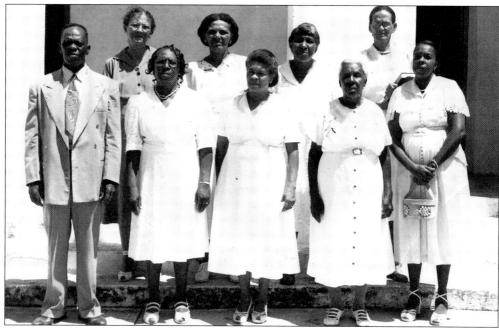

The Deacons Board is a very important organization within the church. These Trinity Presbyterian Church deacons carried on the legacy left to them by their Bahamian ancestors. Deacons were responsible for the maintenance of the church's edifice, the welfare of the pastor, assisting the pastor with the communion of the shut–in church members, and the training of the young adults to become a part of church service.

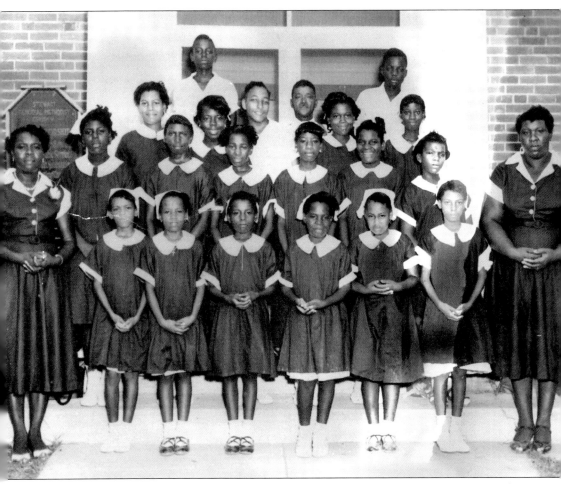

Mrs. Bernice Gallagher (front row, right) was one of the organizers of the Newman's United Methodist Church youth choir pictured here. A great choir organist and pianist for several of the churches in the community, she made a huge impact at her local church as well as others around the state with her music. Music was a basic part of life for the youth in the black Bahamian community of Key West; in some homes it was mandatory study to keep the young from idleness. As entertainment and inspiration, choir singing provided uplifting of the spirit and comfort for the elderly when they received visits at the nursing homes. Choirs have provided wholesome, positive, social activities for the youth. Mrs. Elizabeth Cash, (first on the front row) also assisted Mrs. Gallagher as chaperone for the group when they traveled away from home.

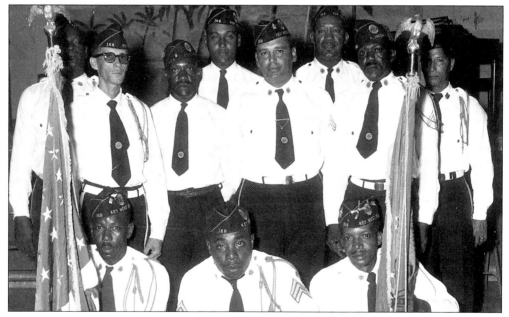

Before World War II, black veterans wishing to join the American Legion could not use the name for their groups. Key West veterans called their organization "The Colored Veterans of World War." In 1946, 15 of the members signed a charter to become Post #168–C of the American Legion naming it after Key West native and World War I veteran William Weech.

This group of veterans from William Weech Post 168 all lent a hand in building the post's home at 803 Emma Street in 1952. From left to right are (kneeling) Samuel Welters, unidentified male, and Valgene Hayes: (back row) Robert Whyms, Anthony Castillo, Alfred Colebrooks, Donzel S. Leggett, Jose Planas, Alfred Allen, Edwin Rolle, and Francisco Castillo.

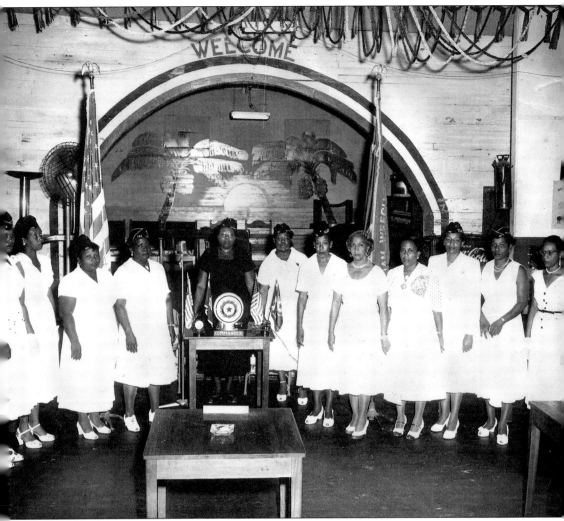

Malvise Pinder organized the William Weech Post 168 of the American Legion Ladies Auxiliary shortly after World War II. This photo was taken of the group at the Dixie Hall (also called Samaritan Hall) located at the corner of Samaritan Lane and Whitehead Street. All organizational meetings were held in the hall, as were dances and other ceremonial functions of all of the fraternal and civic organizations in the black community. The auxiliary worked to raise funds to help build the post home, and they raised funds for social services to disabled veterans. Other community projects included providing limited college scholarships and sending young people to camps and educational workshops.

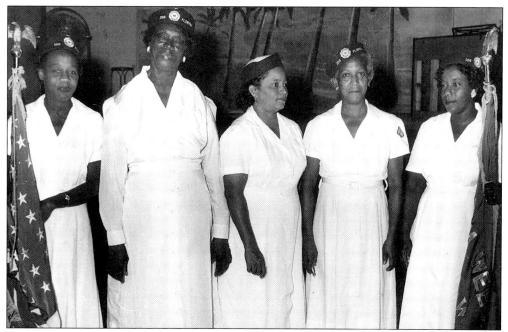

The Ladies Auxiliary of William Weech Post 168 also participated in parades and funeral processions to honor patriotic events, such as Memorial and Veterans Day, and the passing of members. Preparing for a processional march, from left to right are, Mrs. Janice Leggett, Mrs. Flossie Sands, Mrs. Marguerite Planas, Mrs. Antoinette Welters, and Mrs. Winifred Allen.

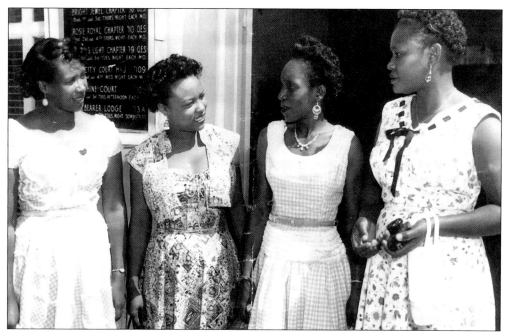

The Ladies Auzillary traveled to conferences throughout Florida. Shown here at a conference in St. Petersburg, Florida, during the 1950s, from left to right, are Mrs. Patricia Allen, Mrs. Louise Roberts, Mrs. Mary Roberts, and Mrs. Carrie Colebrooks.

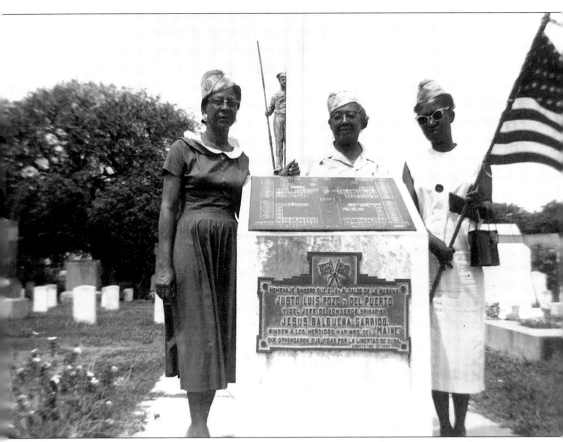

The second black veterans organization in Key West is the Veterans of Foreign Wars. These are the men who fought in any of the foreign wars. The Walter Mickens Post 6021 of the Veterans of Foreign Wars was established during the 1940s and named after the first black Key West native to die in World War II. The organizations had a small membership so they joined with the American Legion and has since shared management of the post home. The VFW Ladies Auxiliary functions similarly to the American Legion Auxiliary. Memorial ceremonies were a specific duty of each post. Shown in the Key West Cemetery at the veterans burial site during a memorial service honoring veterans who died are, from left to right, Mrs. Leoncia Stallings, Mrs. Rowena Pinder and Mrs. Juanita Bennett. Mrs. Stallings's husband Jim was awarded the Purple Heart during Pearl Harbor. Mrs. Pinder is the mother of veterans Archibald and Leslie Pinder. Mrs. Bennett's husband and sons served America despite the discrimination blacks experienced in the military.

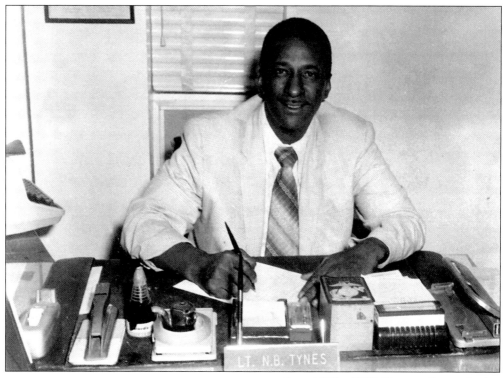

From 1889 to 1893, Monroe County had a black sheriff named Charles DuPont. One hundred and sixty years later, Nathan Tynes became the first black detective at the Monroe County Sheriff's Department, rising to the rank of lieutenant before his 1974 demise. Born in Key West of Bahamian parentage, Lt. Tynes was a devoted family man and also very active in his community, holding membership in several fraternal and veterans organizations.

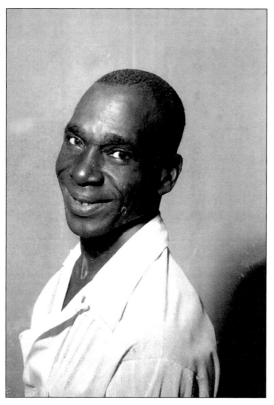

A part of an elite federal policing agency, Key West native Eugene Butler was an extraordinary man. He made tremendous personal sacrifices to serve his fellowman and his country. His job was cloaked in secrecy and uncertainty, limiting time with his family and community. Nevertheless, the work he did protected the people from dangerous criminals and gave him the opportunity to open doors for other blacks to serve as well.

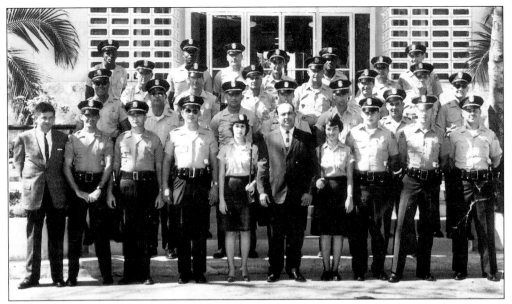

Although small in number, black policemen in Key West acted as surrogate parents to the youth. They were involved with activities for the adolescents and their constant presence on the streets of the black community discouraged violent crimes. The black policemen in the top row of this photograph, from left to right, are John "Pete" Kee, Edward "Cat" Scott, and fifth from the left is Raymond "Tito" Cassamayor.

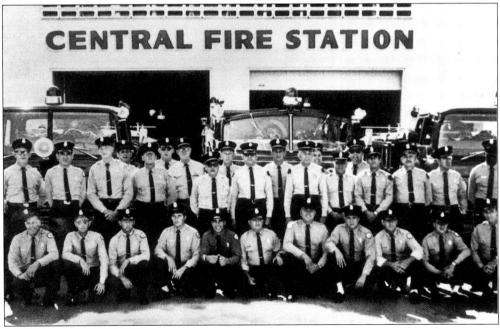

Oscar McIntosh, pictured standing to the far right, was the first African Bahamian of Key West to be "grand fathered" as a certified Key West fireman in 1966 and the second in the state. Bernard "Nardy" McGee served as a volunteer fireman in our community many years before, inspiring Oscar to help protect the community in the same way.

ST. AGNES LODGE #1696, G.U.O. OF ODD FELLOWS

KEY WEST, FLORIDA

March 29, 1951

TO WHOM IT MAY CONCERN:

This is to certify that Francisco Alexander Johnson, was initiated in the above named lodge on the 26th day of June 1920, and the records of the above named lodge show that he was born on the 30th day of June 1885 in the City of Tampa, Florida.

Respectfully yours,

Francisco A. Johnson N. G.

Joseph Hannibal P. S.

The origin of fraternal organizations can be traced back to our African heritage and are many times extensions of a tribe's community. Such groups are the keepers of sacred tribal codes and rituals, and they are a source of spiritual and financial support for families in need. Membership requires an initiation ceremony and a pledge to uphold the rules of the organization, which are based on high moral codes. As a benefit, members acquired cultural identity and fellowship. After being brought to America, Africans began to form societies and lodges to continue these practices. African Bahamians in Key West organized the Odd Fellows Lodge in the late 1800s as a support network for the new immigrants. By the early 1900s, more lodges were formed and many had juvenile lodges for the youth. Among them were the Lilly White Lodge, the Grand Order of the Pallbearers, the Free and Accepted Masons, the Order of Eastern Stars, and the Coral City Elks Lodge.

In the early days, being a member of a lodge or society meant that you were to carry yourself in a respectful demeanor at all times in the public. Pictured here, from left to right, are Kermit Johnson and his uncle, Benjamin Ramsey, both members of the Odd Fellows Lodge. Benjamin migrated here from the Bahamas in the late 1800s and his nephew was born in Key West.

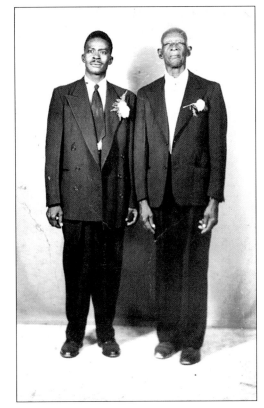

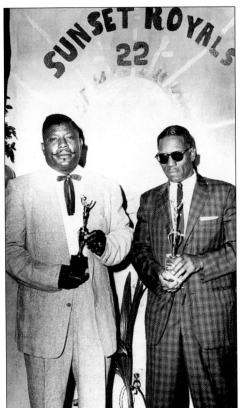

Everyone in the community has a need to belong and to identify with a group of some kind. Social organizations were formed to foster fellowship and to contribute to specific community needs as they arose. Pictured here, from left to right, are Roosevelt Neal Sr. and Edwin "Eddie" Lampkins, members of the Sunset Royal Men's Club. They were rewarded for their untiring dedication to youth sports and the Boys Scouts of America.

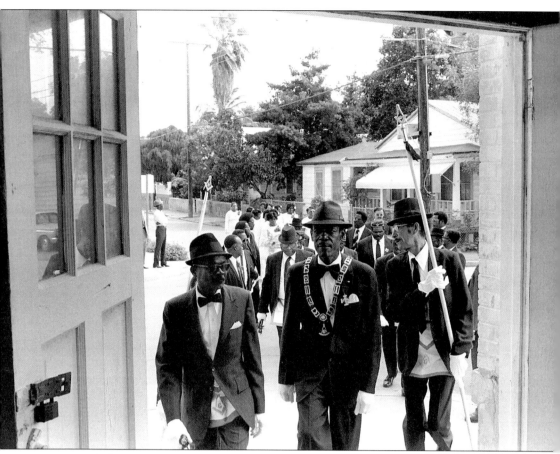

Masonic lodges are secret organizations with brotherhoods all over the world, patterned after men's societies in Africa. During the early 1920s, there were two black Masonic organizations in Key West—the Pride of Key West and the Mount Moriah Free and Accepted Mason Lodge. Since both organizations were small in number, some years later they joined together to form the Union Lodge #47 Free and Accepted Masons. Membership is familial—any male in a family who is a member can present another male relative to the brotherhood for acceptance. One must be of high moral character and possess the willingness to help a brother whenever he gives the secret sign. Secret rituals are a vital part of the organization with the sacrament to the dead performed around the grave the most intriguing of all public ceremonies performed. The group seen here, accompanied in a procession by their female counterparts the Eastern Stars, is dressed in full regalia and is truly an awesome sight to behold.

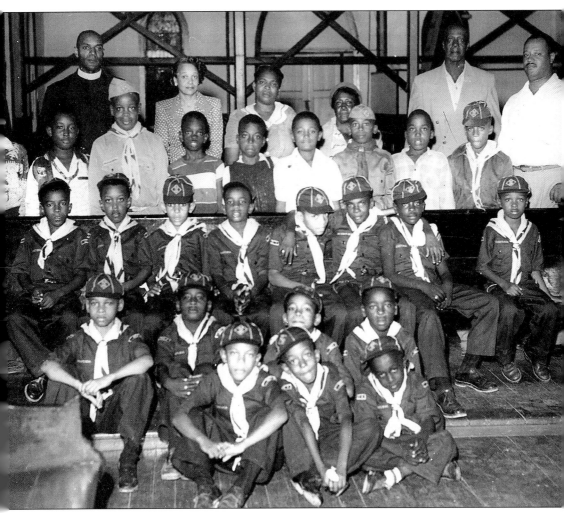

The Boys Scouts of America played an important role in the Key West community. There were three or more troops for boys ages 6 to18. All of the troops originated in the church. The troop pictured here was started at Cornish Memorial A.M.E. Zion Church. They met at the church and were kept busy with field trips, campouts, and various community projects. They were also taught survival skills and how to be trustworthy. The organization gave them a sense of belonging, and it kept them out of trouble. The entire community supported the troops and many became successful in adulthood. Den mother Ruby Bain (last row, second from the left) was loved and remembered even in death. Six of her boy scouts volunteered to be pallbearers at her funeral.

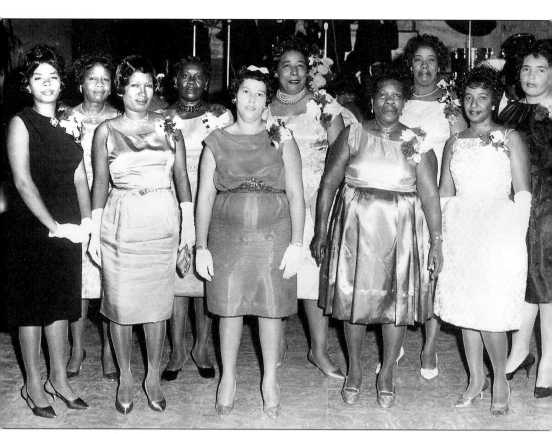

Brownie and Girl Scout Troops of Key West's black community aspired to be like these well-dressed women when they grew up. Silverette Club members, from left to right, are (front row) Mrs. Dorothy Davis, Mrs. Juanita Bennett, Mrs. Vivian Woods, Mrs. Susan Davis, and Mrs. Lucille Small (Myatt); (second row) Mrs. Janice Leggett, Mrs. Agnes Smith, Mrs. Lenora Tyler, Mrs. Elizabeth Stocker, and Mrs. Gloria Wallace. The social club is a counterpart of the Silver Slipper Men's Club, which provides a place for shared interaction. Part of their profits is set aside for children's programs and college scholarships. The club also visits churches and contributes to the support of the congregations. Yearly anniversary celebrations are exciting events for the members as they bring in outstanding speakers to address the group and their guests. They also visit and carry care packages to sick and shut-in members in the community.

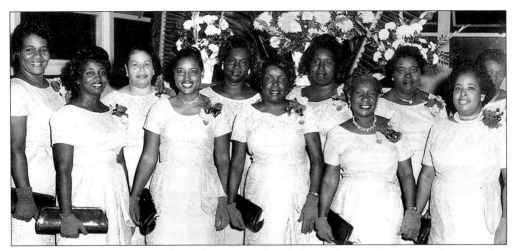

The Regular Deluxe Club members, shown here from left to right, are (front row) Mrs. Ernestine Curry, Mrs. Ellen Evans, Mrs. Violet Curry, Mrs. Rosalie Fisher, and Mrs. Geneva Whalton; (second row) Iris Williams, Mrs. Louise Summers, Mrs. Victoria Roberts, Mrs. Alfredina Butler, Mrs. Elizabeth Cash, and Mrs. Susie Hannibal. They also supported black high school graduates with scholarships.

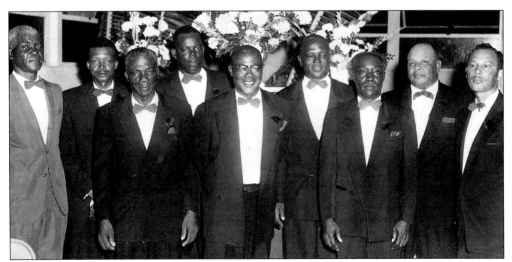

The men of the Regular Fellows Club are the mates of the Regular Deluxe Club. From left to right are the following: (front row) Cyril Fisher, Walter Curry Sr., and Leroy Summers; (back row) Audley Cash, Valgene Hayes, Walter Curry Jr., Ernest Williams, Floyd Hannibal, and Harry Evans.

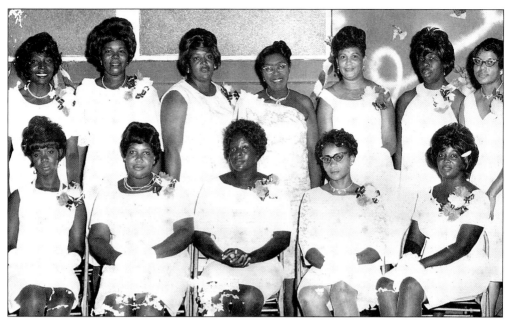

The Royalettes Club members had monthly meetings and "Fun Nights" to raise money for their community projects. From left to right are the following: (front row) Mrs. Genie Haggins, Mrs. Deloris Scott, Mrs. Wonder Lee Curry, Mrs. Sylvia Allen, and Mrs. Ernestine Curry; (back row) Mrs. Joanne Poitier, Mrs. Sarah Curry, Mrs. Theodora Ward, Mrs. Shuler Alexander, Mrs. Sylvia McIntosh, Mrs. Doris Smith, and Mrs. Betty Cox.

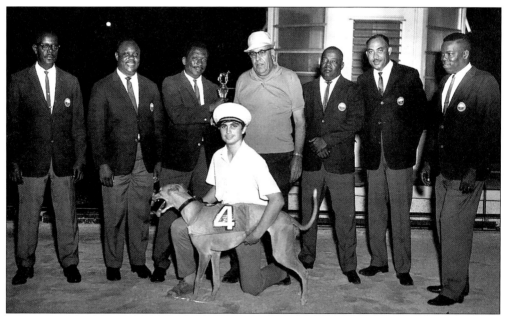

The Royal Deluxe men's club had a very visible presence in the Key West Community. They often attended the Key West greyhound races for entertainment and fellowship. The very impressive group of members, from left to right, includes Solomon Scott, James Smith, Gerald Poitier, an unidentified male, Gilbert Curry, Edwar Weech, and Walter Curry Jr.

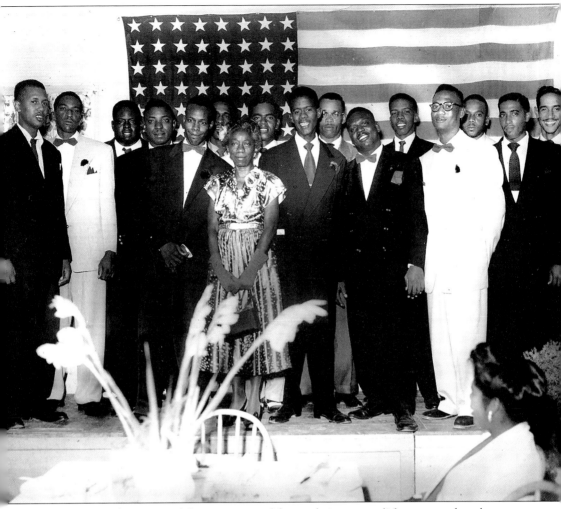

The men's groups have annual banquets to celebrate their accomplishments and to honor distinguished community members for their public service. Members of the community are invited to their banquets to help celebrate the honoree. The Regular Fellows Club honored Mrs. Ellen Sanchez (center) in the late 1950s. The granddaughter of highly regarded musician Frank Welters, founder of the Welters Coronet Band, she followed in his footstep with her love of music. She has taught many children in the community to play her favorite instrument, the piano. She taught her godson, Lofton "Coffee" Butler, who has become a legend in Key West. Mrs. Sanchez loved children but had none of her own. She established her own kindergarten to teach children and to share her love of music. Mrs. Sanchez directed full-stage plays of her written work with the children and the community looked forward to her productions each year.

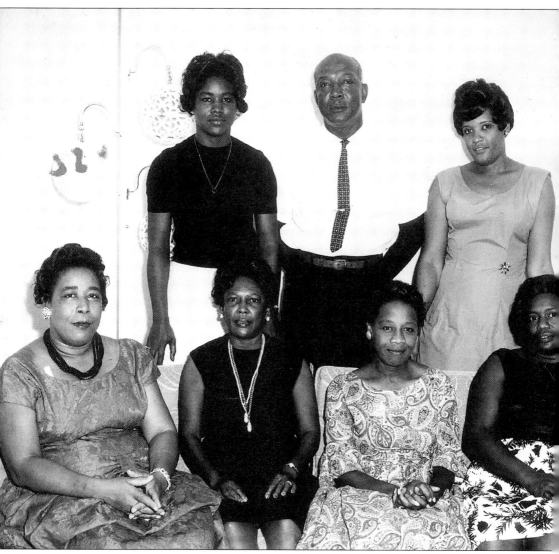

The Key West Chapter of the National Association for the Advancement of Colored People was the first established in Florida during the 1920s. Even before then, blacks in Key West were very visible and vocal during the 1800s, as free African men were very involved with the politics of Monroe County and Key West. Monroe County James Dean was elected November 6, 1888, as the first black judge in the state of Florida after Reconstruction. The Key West Chapter of the NAACP brought the first school desegregation lawsuit to U.S. District Court in 1964 and won a final decree to desegregate on May 4, 1965. They never backed away from a valid case. The executive committee members, from left to right, are (seated) Mrs. Lenora Tyler, Mrs. Lorene Jenkins, Mrs. Janice Leggett, and Mrs. Ora Morrow; (standing) an unidentified female, Mr. Bobby Welters, and Mrs. Arlene Bessilu.

Six
CULTURAL CELEBRATIONS AND FESTIVALS

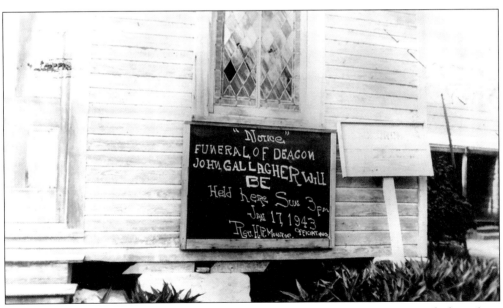

In Key West, as in African culture, when someone passes on, preparations are made for at least seven days of customs. The death is announced to the family, travels plans are made, food is prepared for the day before and the night after the funeral, and the interment program is planned with the minister. This sign announces the death of one of Zion Primitive Baptist Church's founding members.

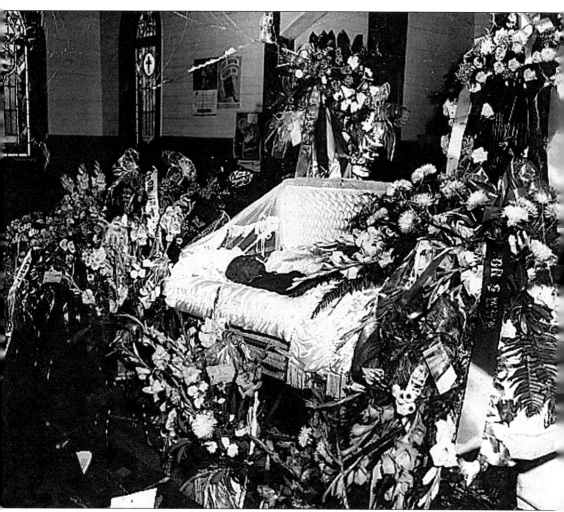

Honoring and celebrating the dead is still a cultural tradition in Key West. In the Yoruba culture, Africans bury their dead with gifts. In America we send elaborate floral arrangements with them. If you are highly respected in the community and are a dedicated church worker, you can be laid-in-state at your church. Up until the early 1970s in Key West, most families brought the remains of their loved ones home to spend one last night before burial. In African culture, the remains are sometimes buried in the ground of the living quarters, so the spirits of the ancestors will always remain with them. The wake on the night before brings family and community together to reflect and comfort one another. It is also time to get a good look at the story the floral arrangements tell of the love felt for the deceased. The broken wheel, the empty chair, the bleeding heart, and the family spray are all arrangements sent by members of the immediate family.

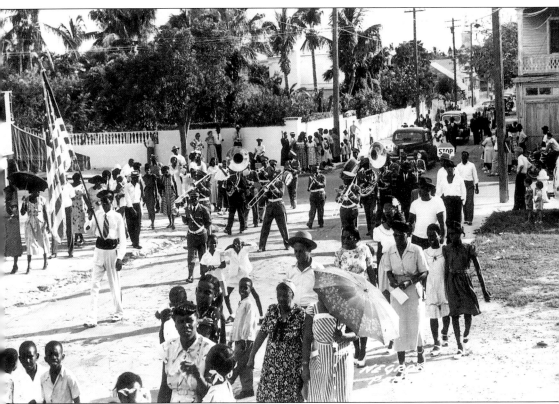

The funeral procession with the Welters Coronet Band has been a cultural tradition for years. Members of the VFW, American Legion, or any of the other fraternal organizations; local politicians, and decorated law enforcement officers all had the band played at their funeral. Other people could have the band play at their funeral if they could afford it. The Welters Coronet Band is seen here leading the funeral procession of Otis Skinner, a well-known bar bouncer at Sloppy Joe's Bar. According to the Yoruba culture, the music played is meant to soothe and guide the spirit of the deceased along the processional through the community on the way to the final resting place. On the band's return from the cemetery, the funeral dirge is replaced by a lively celebratory processional with some dancing in the streets.

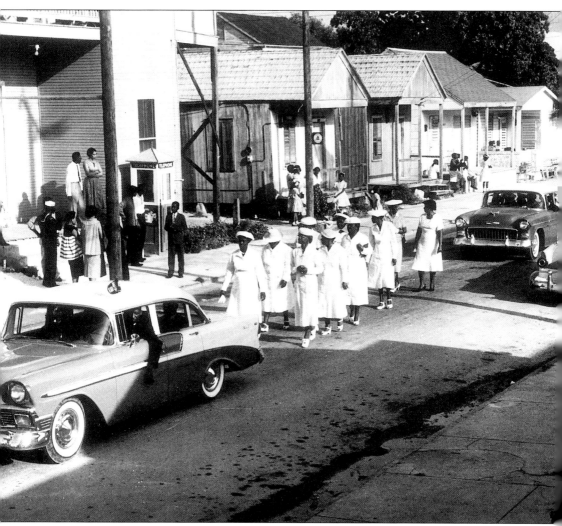

Funeral processions are sad parades for fraternal organizations, especially when the deceased is a member. The highest esteem is given when the entire lodge marches in the funeral procession, some wearing black armbands or special badges at the funeral ceremonies. At the church and at the grave of the deceased, rituals are performed as final farewells. This is part of the lodge's sacrament to help send the spirit of their departed member to the next life. All women's groups wear white, which helps keep them cool as they march in the procession. Comfortable shoes are a must, but an extra car is always available in case a member succumbs to the heat or grief. However, usually the sound of the funeral dirge music sways the body and encourages the feet to continue up Solares Hill and on to Key West Cemetery to bury the dead.

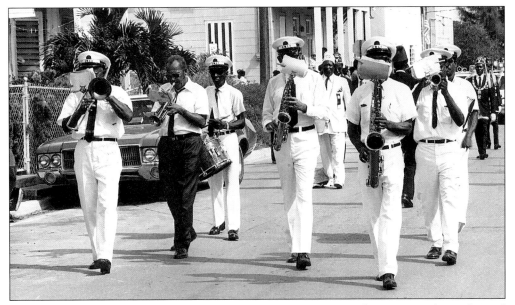

Dressed in their cool white uniforms, the Key West Coronet Band carries on the traditional funeral dirges of the Welters Coronet Band. Frank Welters (second left, first row) is a direct descendent of the founder of the Welters Coronet Band. Welters's cousin, Frank Flukers, also played with the Welters Coronet Band. Leading the Elks lodge in a funeral procession, these men are the third generation of band members.

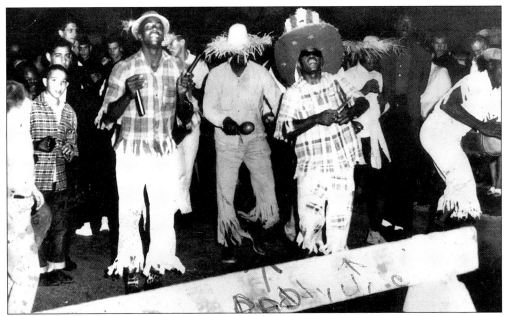

The Key West Junkanoos is a group of locals preserving and enjoying the music of their African-Bahamian-Cuban ancestors. Members of the group are all related. Their African beat and Bahamian lyrics make a combination that keeps one on their feet. The group welcomes tourists to the island with their native musical performance. Members are Joe Whyms, Charles "Bookie" Allen, Leonard Allen, Alvin Scott, and Kenneth Rahmings.

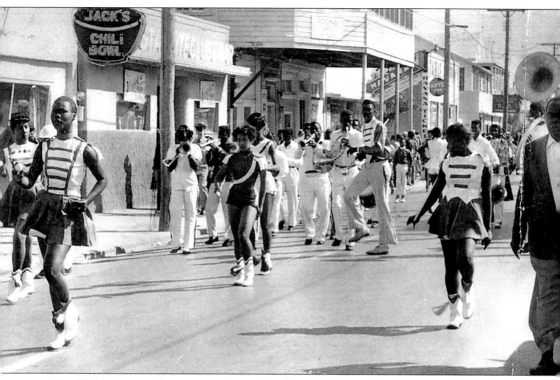

The Christmas parade was a tradition for all Key Westers, but for the black community the parade was an opportunity for them to see the Douglass High School Band perform. With the majorettes and bandleader Eugene "Bishop" Butler leading the group with their high steps, a crowd of excited fans always walked alongside the band during parades. Bandleader George Dean was always alongside the band to keep them under his watchful eyes and ears. The band traveled to the Miami Classic parade, a traditional gathering of two rival African-American colleges vying for victory in the annual football game. The parade gave the marching band an opportunity to present their "best" performance to the citizens of Florida and to compete gallantly for a trophy from the parade.

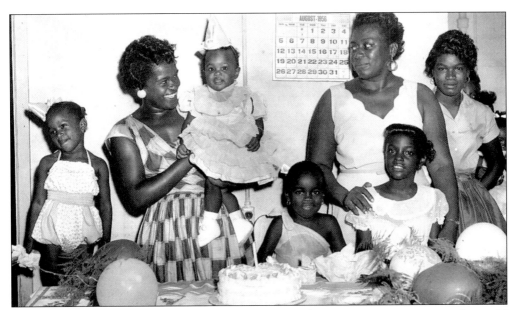

Birthdays are special events in most households everywhere. In Key West, parents who could not afford a big party to celebrate would still have a birthday cake with candles and ice cream. At this party, little Alexandra Reeves, a fourth-generation Key Wester, is held by her mother Barbara Reeves while celebrating her first birthday with grandmother Marion Sands and aunt Artherine.

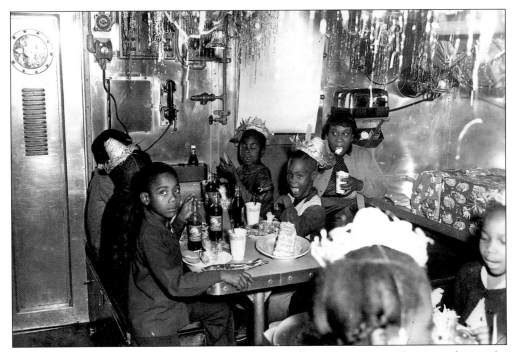

Blacks in Key West had a paternalistic attitude toward the navy. Every Christmas during the 1950s, the navy would give their civil service employees gifts for their children. Here is a very special birthday party aboard a ship for a boy whose grandfather was a civil service employee. He received special permission to have the party.

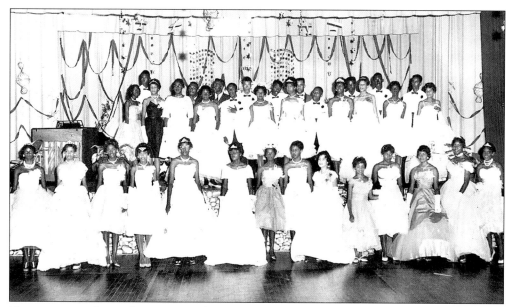

The prom was a big tradition at Douglass High School. For many years, juniors and seniors had their proms together. Unwittingly, this was an unrecognized ritual of seniors passing down tradition to the juniors. It was also an exciting time when many girls were allowed to dress like adult ladies for a date with young men dressed in their "after five" attire.

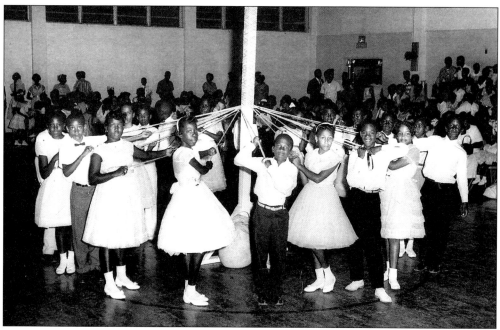

Junior and high school students looked forward to the end of the year prom. The middle school students looked forward to the May Day Celebration, which takes place just before Easter vacation. The students chosen to participate dress up in their Sunday best and become the center of attention as the whole community watches them plait the traditional May Pole at the culmination of the May Day Festival.

Seven
ENTERTAINMENT

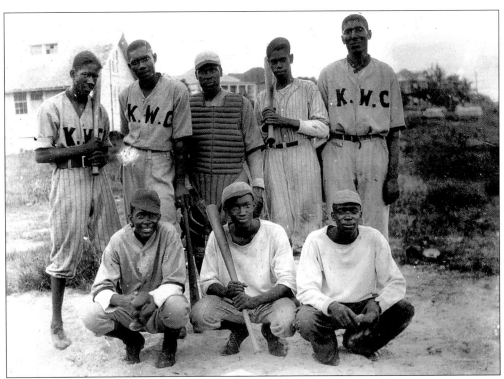

Baseball was a major form of family entertainment for blacks in Key West from the early 1900s through the mid-1970s. The Key West Coconuts of the 1920s were highly competitive in games against other teams in Key West and Florida. Members, from left to right, are (kneeling) Pedro Suarez and Richard and Charles Williams; (standing) Cecil Bain Sr., Charles Storr, Roosevelt Sands, Eugene Smith, and George Dean.

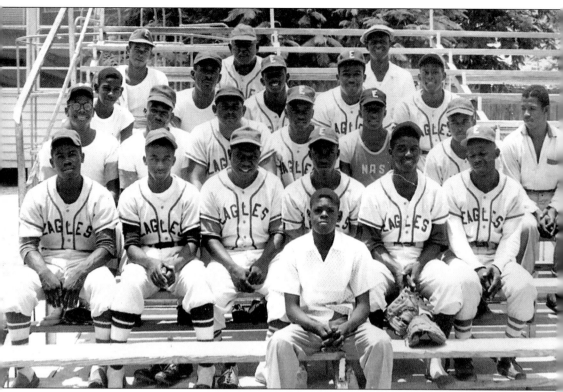

The second generation of Key West baseball players during the late 1950s were as full of energy and love for the game as their predecessors, the Key West Coconuts, were. They were real champions to their Key West fans. The Key West Eagles members and team staff are seen above in this 1956 photo. Seated in the center is team assistant Dan "Cherry Red" Miller. From left to right are the following: (first row) Maxwell "Macky" Hudson, Emerson "No. 9" Allen, Lofton "Coffee" Butler, John "Dickie" Fields, James "Rock" Poitier, and Roosevelt "Buddy" Carey; (second row) Cecil "Chip Chip" Terry, Joseph "Joe" Kee, Renaldo "Horsey" Valdez, Oscar "Sugarfoot" McIntosh Jr., Charles "Larry" Brown, and Kenneth "Crip" Carey: (third row) Alvin "Grasshopper" Scott, Curtis "BeBop" Brown, Robert "Bolleo" Butler Jr., Ralph Welters, and Donald "Duckie" Carey; (fourth row) Wendell "Ching Wendy" Gallagher, John "John Bread" Sands, and Bernard "Nardy" McGee. (Courtesy of Mrs. Martha Butler.)

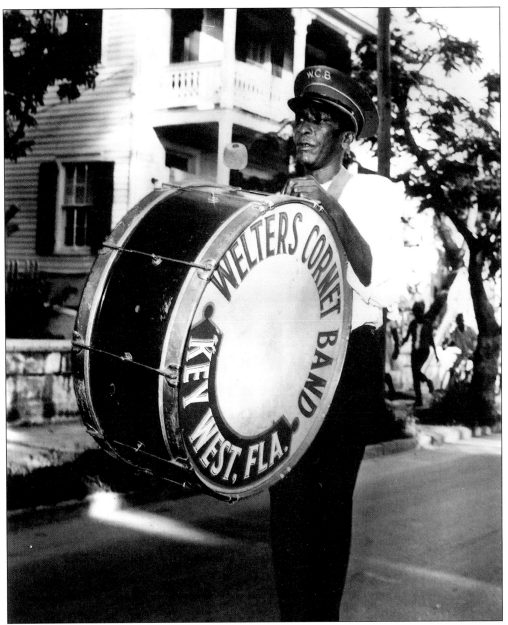

The Welters Family carried on the tradition of playing in the funeral band for over 80 years. Frank Flukers's mother was a direct descendent of Frank Welters, founder of the Welters Coronet band. The family enjoyed music and was generous with their musical talents on programs and concerts throughout the city. They played for private parties and public ceremonies. Frank Welters played several instruments, but the clarinet was his favorite. One of his grandsons played the trumpet while his granddaughter, Ellen Sanchez, plays and teaches the piano. Frank Flukers, also a grandson of Frank Welters, is pictured here playing the bass drum. It appears that he has the most difficult job of all the band members—carrying the big drum, beating it, and walking in step with the others for 45 minutes non-stop.

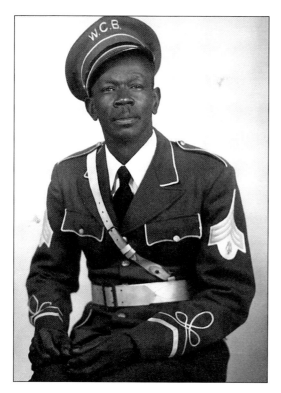

William "Bill" Butler was the consummate entertainer. He came from a home that encouraged and participated in musical ensembles all over Key West. Handsomely dressed in his Welters Coronet Band uniform, Mr. Butler played the tuba, bass drum, bass guitar, and piano, and he sang deep baritone.

Male choirs originated in the church and sang on church programs once a month. All of Bahamian descent, this male choir of Trinity Wesleyan Methodist Church is all related. They sang traditional hymns of the Methodist church and were very popular because of their beautiful harmony, rich tones, and reverence they had for the art of song. They also sang for special events and fund-raisers for the church.

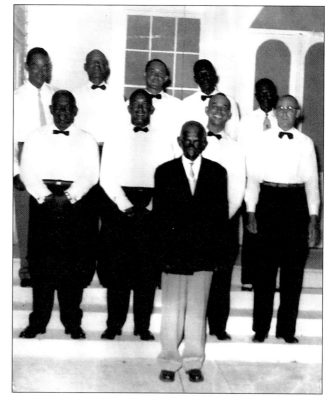

Segregation forced blacks to entertain themselves, while whites benefited from all types of entertainment. Groups like the Honey Boys, shown here, were hired to play at private parties and dances even in the white community during the late 1930s and 1940s. Members, from left to right, are the following: (front row) David Bain, Bernard Chacon, and Harry Ferguson; (back row) Henry McKinney and James Gabriel.

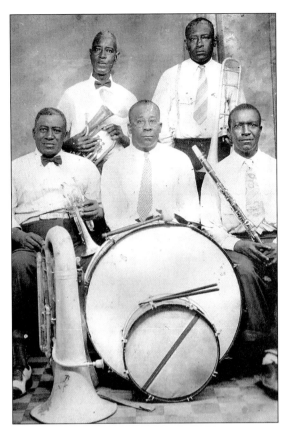

When Theodore "Fats" Navarro, shown below on the far left, left Key West after graduating from Douglass High School in 1941, he had already played with the big band Walter Johnson Orchestra in West Palm Beach, Florida. He was already a devoted jazz virtuoso destined for fame. He entertained the crowds with his trumpet at parties and dances in Key West with fellow musicians Willie Austin, Kermit Saunders, Harry Chipchase, and Oliver Butler.

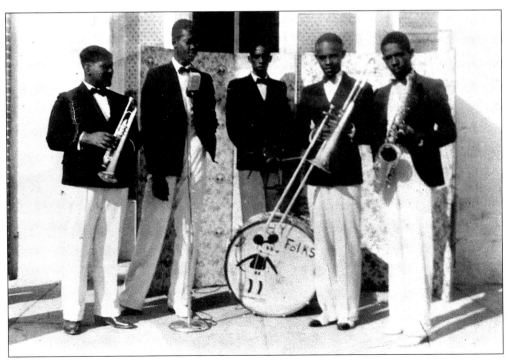

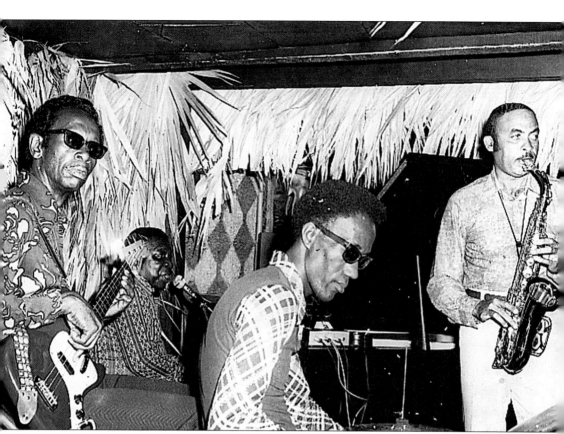

"Coffee and his Cups" played mostly venues on the Key West entertainment circuit. The circuit included the famed Bamboo Room on Smith Lane, Howie's on Duval Street, and the A & B Lobster House. Coffee's quartet played popular tunes, calypso, and smooth jazz that kept the crowds asking for more. The band members, from left to right, are bass player Robert Butler, drummer Howard Nickerson, and saxophonist Edwar Weech.

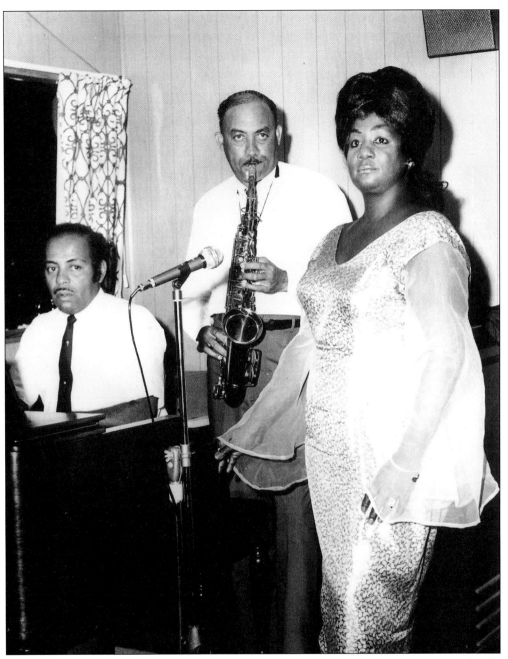

There were many opportunities to play music in Key West during the late 1950s and early 1960s. The military was here in full force, creating a demand for entertainment. This trio, which consisted of retired Navy Chief Freddy Green on piano, Edwar Weech on saxophone, and songbird LaVerne Williams, were in great demand around town for small weddings, cocktail parties, and community dances. The group also played at the Naval Officers Club.

Nathaniel "Miller" Richardson was the "people's entertainer" because he used the beautiful voice God gave him to entertain some and provide blessings for others. He organized and performed in many fund-raising benefits for families in need and for organizations throughout the black community, especially the VFW-American Legion Hall, of which he was a faithful member.

This group of high school buddies named themselves "the Dolphins," after a popular Key West fish. Singing, from left to right, are Wardell "Cooley" Hanna, Gilbert Gonzalez, Otis "O.J." Hester, Eugene "Bishop" Butler, and Willie C. Haggins at the mike. The young idols were popular for high school dances, proms, and parties with their renditions of 1950s favorites.

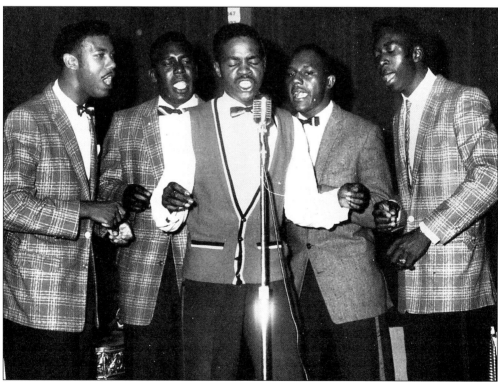

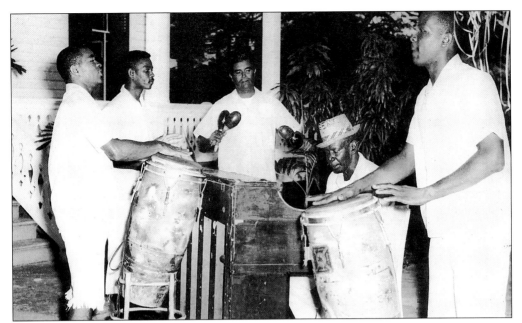

During the late 1960s, native island music was in great demand. The original Key West Junkanoos are, from left to right, Leonard Allen, playing the congo drum; Alvin Scott; Charles "Bookie" Allen; William "Bill Butler" with vocals at the piano; and Kenneth Rahmings on the congo drum. The group traveled throughout the States during the mid-1970s as Key West Ambassadors with their unique brand of African-Bahamian music.

The tradition of Junkanoo music and entertainment will continue to be passed down from generation to generation as illustrated here with the Key Wes Jr. Junkanoos. They imitate the elders, are third generation Junkanoos, and are all related. From left to right are the following: (front row) Robert Pelote and his brother Harold; (back row) brothers Alexander and Ellison Williams and Hillard "Kiss" Lang.

Children in Key West were not shy about performing in the community or for the tourists who graced the tropical island. During the 1940s young boys would dance openly in front of the Ernest Hemingway's house with soda caps between their toes to gain attention of tourist passing by or visiting the famous mansion. Some days they would earn enough money for their favorite candy or cake.

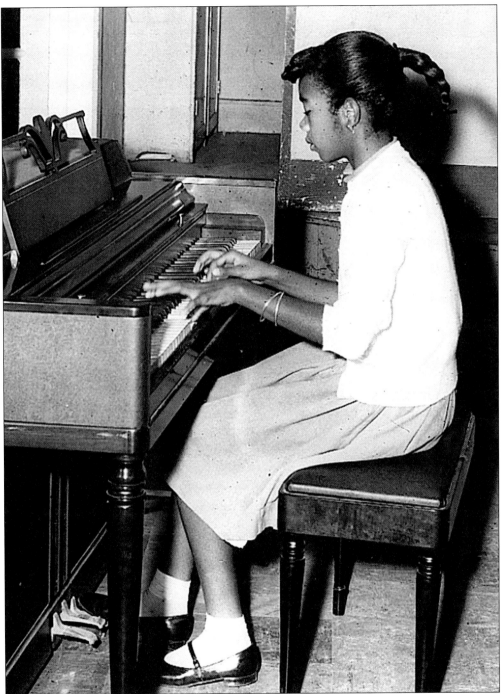

On a more refined note, some black children were taught classical music at the Catholic convent before public schools integrated in the 1960s. This exposure gave the children an opportunity to learn to appreciate music from other cultures and the confidence to perform music in formal settings. The symphony performed in the Christmas play every year to a packed auditorium of family and friends.

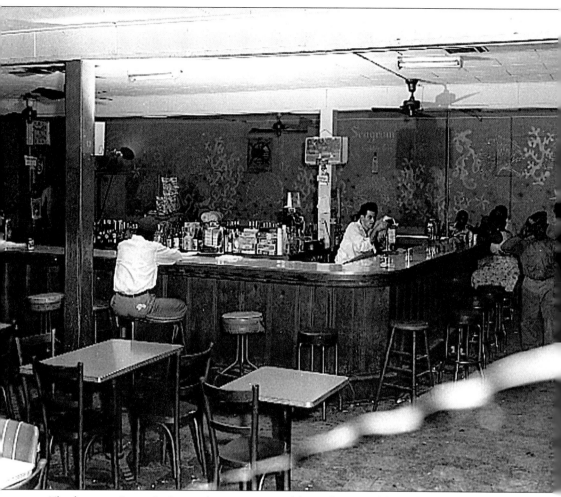

The bars on Petronia Street that were owned by Cubans and local blacks were a source of entertainment and socializing for the many military men and fishermen that called Key West homeport. Shorty's bar, shown here, was located one block off Duval. It was a large and popular hangout for locals and regulars alike. A whole lot of dancing and drinking went on inside this prime entertainment spot.

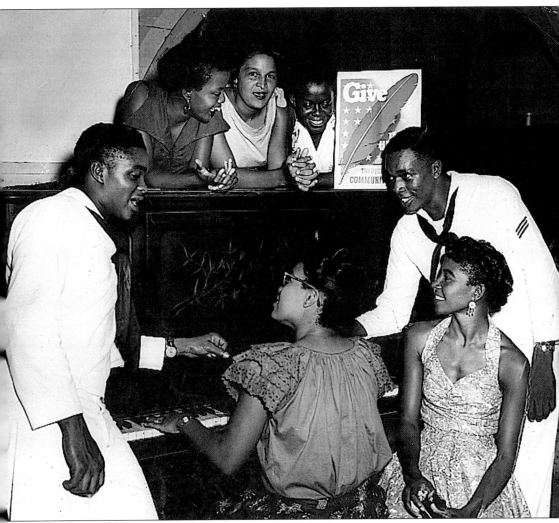

The Colored USO provided safe, clean entertainment for young women in the community who volunteered to participate in structured, chaperoned activities with visiting servicemen during the early 1960s and mid-1970s. A home away from home, the USO sponsored dances and special holiday programs for military personnel stationed in Key West but at segregated locations. In 1966, both organizations integrated and shared a building at 530 Whitehead Street.

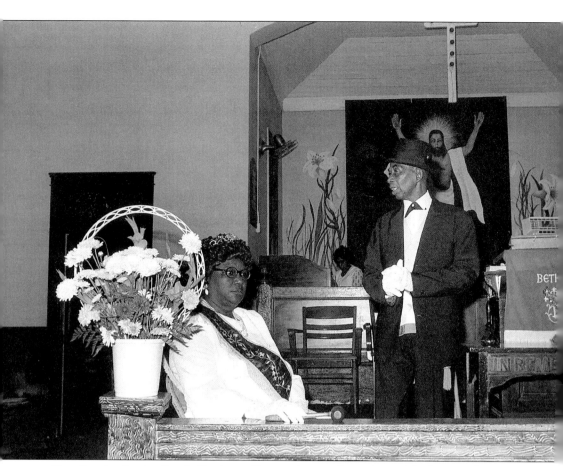

Mrs. Bernice Louise Sands Hepburn Shavers is seen here dressed in her regalia as Worthy Matron of the Key of the Gulf of the Easter Stars. Mrs. Shavers holds the distinction of being the only female ever allowed to be a member in Key West's all men's regular fellow club. She was a community servant, nurse, insurance agent, and devoted member and organist of Trinity Presbyterian Church.

Eight
LEGENDS AND LANDMARKS

The most virtuous, blessed legend of the black Key West community was Sister Myrtle Catherine. Born and raised in Key West as a devoted Catholic, Myrtle became the first black nun from Key West and the first black accepted into the Order of the Convent of the Transfiguration in Columbus, Ohio.

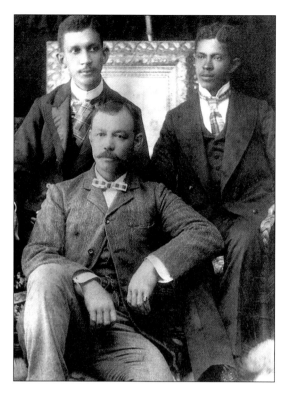

Prominent black families were actively involved with civic affairs and politics during the mid-1800s, and these young friends were a part of that middle upper-class group. Seated in the center is Henry Fleming, a white Bahamian businessman who married a black Bahamian woman. To his left is Mr. Wheeler, a comrade. George English, a U.S. Customs inspector is also pictured.

Frank Welters was the most inspirational musical legend of Key West during the late 1800s. He was born to free African parents who migrated from St. Augustine, Florida. Frank organized the "State Champion" Welters Coronet Band around 1884 and a jazz ensemble in which he also played. He taught and inspired all of his musical offspring along with young men and women in the community who were passionate about music.

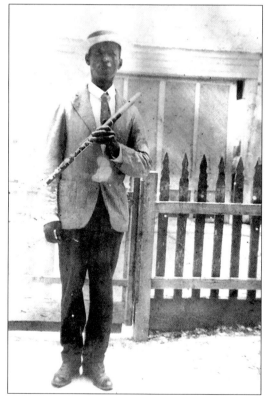

Robert Gabriel is the political legend of black Key West. He set an example for black self-determination throughout Florida. Mr. Gabriel served admirably as Key West City Commissioner in 1876, 1878, and 1879. He then became the first black in Key West to represent Monroe County in the Florida House of Representatives in 1879. Later, he was re-elected as Key West City Commissioner from 1905 to 1909.

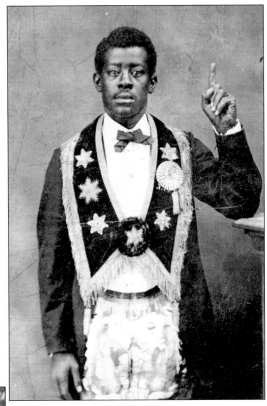

Celestine Ingraham Farrington Evans was a "matriarchal legend." Emigrating to Key West from the Bahamas in servitude at age 12, "Miss Sally," as she was affectionately called, was always in charge of "running the house." Her spirituality, honesty, management ability, and "no nonsense" attitude earned her the position of "Matron" of the Monroe County Colored Old Folks Home, or the "Poor House," after successfully rearing her eight children.

Native Frank E. Pinder is the epitome of black Key West's contribution to humanity. He is our "International Legend," one who, as a child, absorbed from the African-Bahamian ancestors, who were freed or escaped slaves, the love of African culture, especially the agriculture. Untiring dedication and brilliant work in the U.S. Foreign Service throughout Africa brought him international recognition and a place in American history as a great humanitarian.

Lang B. Milian was born in Key West on April 3, 1921, into a family with a long line of educators, professionals, and political activists. He was a devoted Catholic and a World War II veteran, and he was active in numerous community organizations. His most notable accomplishment was his election to the Key West City Commission in 1971, becoming the first black elected since Robert Gabriel in 1909.

Wearing the derby of an esteemed African-Bahamian gentleman, Roosevelt Sands Sr. is a "giant community legend" in black Key West. Born in Key West in 1901 to Bahamian parents, Mr. Sands lived and served the community of Key West all of his life. A devout Christian, family man, and great baseball player, Mr. Sands was a member of many community organizations and a perfect leader for children to follow.

George Cambridge was born in Key West in the late 1800s and was raised in St. Peter's Episcopal Church. He was a devoted member and served in every capacity in the church. As an adult, he became one of the leading fund-raisers for the church. He was a successful entrepreneur, a distributor for the black *Pittsburg Courier* newspaper, and owner of his own taxicab and several parcels of rental property.

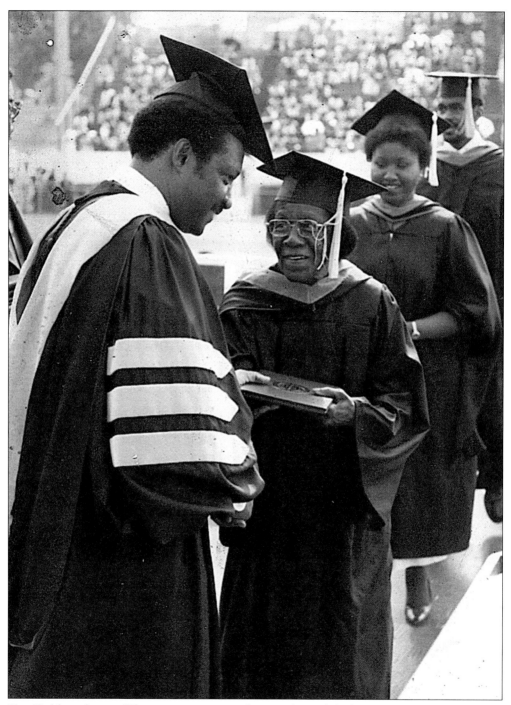

Mrs. Kathleen Sawyer Whyms was an extraordinary role model. She personified the true spirit of African-Bahamian women—aggressively intelligent, industrious, and born to teach. Her determination to succeed resulted in adding to her list of accomplishments a master's degree in education from Florida A & M University in her late 60s. She was a hairdresser, music teacher, substitute teacher, and florist.

The title of "Boxing Legend" would have to go to Kermit "Shine" Forbes for the notoriety he brought to black Key West when he accidentally knocked out famed writer Ernest Hemingway during a sparring bout between two other local boxers. Shine was a fierce boxer and Hemingway liked sparring with him. He was also a caring and kind man, always sharing what he had with others, oftentimes, denying himself.

Key West's "Drum Major for Justice and Equality" is a title Charles A. Major Sr., one of the black community's most respected civic leaders, has earned. Although a carpenter by trade, Mr. Major possessed the skills of a great negotiator. He was able to negotiate compromise in almost any situation presented to him, including the development of the 1964 plan to desegregate the Monroe County School System in 1965.

This landmark case was brought to the U.S. District Court by NAACP President Charles A. Major against the Board of Public Instruction of Monroe County and on behalf of his minor son Joseph Major, a student in the segregated Monroe County school system. The plan for desegregation of the Monroe County School System in 1965 was the first in the nation approved by the courts and peacefully implemented.

Robert "Mike" Whyms was brought to Key West at the age of three from Andros Island, Bahamas. A very hard-working, family man, Mike was the father of 10 children and he raised all of them in a closely knit, loving, spiritual home environment. One of black Key West's only truck drivers in the 1950s, Mike became the first black hired by Lopez Wholesaler's beer distributorship.

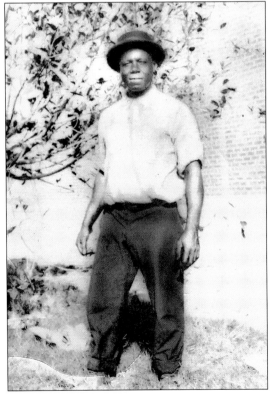

When the big migration of Bahamians began arriving in Key West in 1891, Lofton B. Sands was somewhere in those numbers. He arrived in Key West with a skill that proved to be very beneficial to his family's economic well-being—he was an electrician. Consequently, he was hired by the City of Key West as its master electrician. At one time, he controlled all of the electricity for the city.

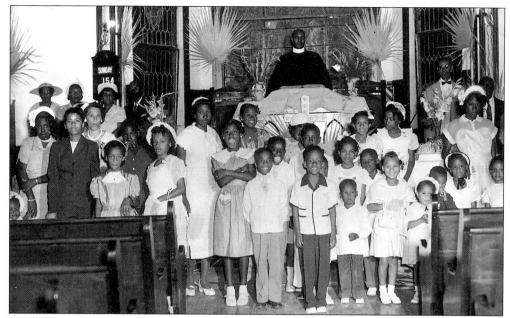

Most black ministers were merely visitors to Key West, only serving a congregation for a specified time. However, Rev. Franklin Hooper was a hardworking, dependable, committed leader in the Key West community. He was pastor of historic Cornish Memorial A.M.E. Zion Church during the mid-1950s to mid-1960s. He taught the bible, counseled the youth, and still made time to participate in civic endeavors.

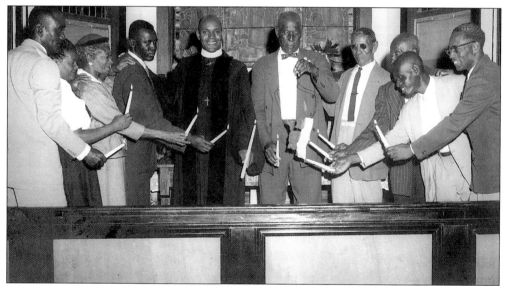

Another landmark event celebrated by the early black churches in America is the ceremonial "burning of the church mortgage papers," declaring clear ownership of the property. The special ceremony photographed took place at historic Cornish Memorial A.M.E. Zion Church on November 22, 1958. The Trustee's Board, from left to right, are Augustus Morgan, Lucille Pope, Atlanta Jemison, George Sands, Rev. Franklin Hooper, George Dean Sr., Gilbert Albury, Leon Sumner, and Eddie Lampkins.

Winifred Sands Johnson shared Bahamian and Cuban ancestry and was raised as a devout Catholic. Her mother made sure she knew Cuba, and her father helped her to become an educated woman. Mrs. Johnson was an excellent educator and the first black columnist for *The Key West Citizen's* weekly colored news section from the 1950s to the late 1960s.

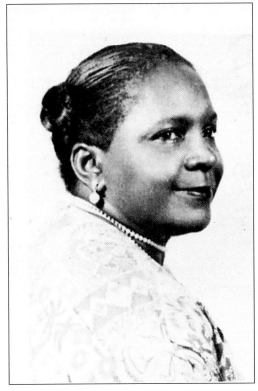

In 1946, Mrs. Marie Welters was elected the first president of the VFW Post 168 Women's Auxiliary, and in 1958 she became the first director for Key West's black USO. She provided leadership in the community through membership in many civic organizations and was a devoted member of St. Mary's Star of the Sea Catholic Church. She was revered for her compassion, beautiful personality, and radiant smile.

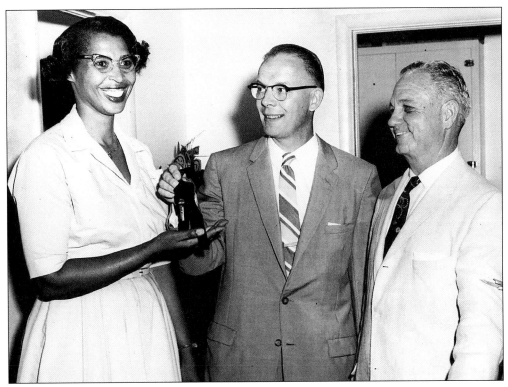

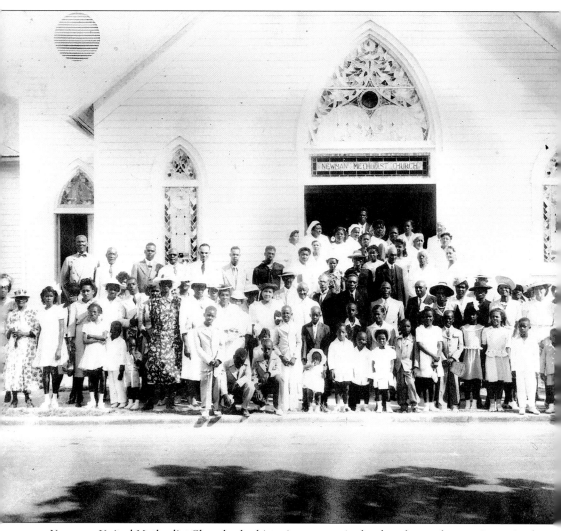

Newman United Methodist Church, the historic community landmark seen here as it was in the 1940s located on Division Street (today's Truman Avenue), still is a comforting and welcoming sight to visitors upon entering the black neighborhood of Key West. In the late 1800s, locals referred to Newman as the church for the "new 'mericans" (referring to black newcomers to Key West with parentage other than Bahamian or Cuban). These "new" members were from the southern states of Georgia, Alabama, North Carolina, and South Carolina. Some were former residents of Virginia, seeking a safer, better way of living. They were devoted Christians and educated professionals working in the capacities of government officials, teachers, and enterprising entrepreneurs. Local African-Bahamian craftsmen constructed the beautiful wooden building. Years after it was built, the Freedmen's Aide Society was given permission to build a school on the lot next to the church to educate black youth in the community. The school was closed after the hurricane of 1912 blew down the building.

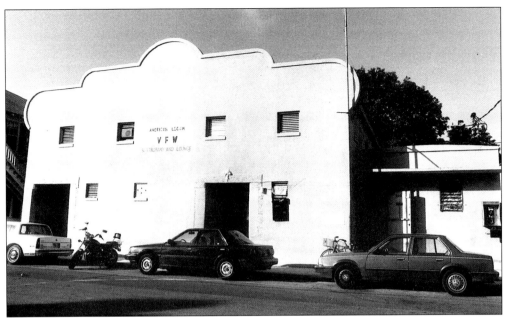

The VFW/American Legion Hall was built at 803 Emma Street in 1952 and also serves as the black meeting place for the community. Architect C.B. Harvey was instrumental in the design of the building, donating his architectural services. The hall boasts a large, beautiful terrazzo dance floor and a full service bar. Many visiting stars performed on the stage, and many community talent shows were also produced on stage.

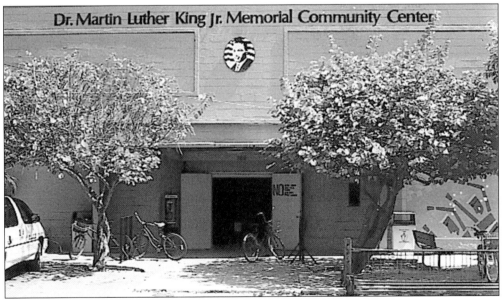

During the early 1900s, the black community of Key West had easy access to the Atlantic Ocean from the neighborhood. When the Navy began its expansion in Key West around that community during World War II, blacks were forced to give up the beach and their property for little or nothing. This public pool was built to assuage the community. Today, it is the only public pool in Key West.

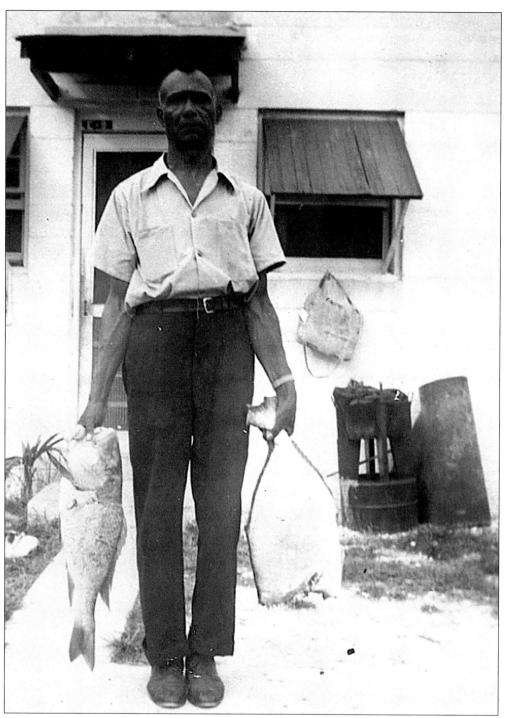
Black fishermen of Key West caught jewfish, groupers, yellowtail snappers, and grunts that helped feed many poor families during the Depression. Such men are truly legends of their time, as is Albert Ernest Sawyer Sr. and other commercial fishermen who lost their lives fishing at Cedar Key, Florida, during bad weather in the early 1940s.

KEY WESTERS KILLED IN ACTION IN WORLD WAR

WORLD WAR I

William Weech	US Army

WORLD WAR II

Harry Knowles	US Army
Walter Mickens	US Navy
Joseph McGee	US Army
Gerald Roberts	US Army
Leon Roberts	US Army
Francisco Romaguera	US Army
Howard Sands	US Army
Franklin Saunders	US Army
Ralph E. Sawyer	US Army
Charles Thompson	US Army

KOREAN WAR

Henry Carey	US Army

VIETNAM WAR

Leland W. Albury Jr.	US Army
William C. Barnes Jr.	US Army
Oliver Coleman Jr.	US Army

DESERT STORM

One key West son killed in action in that conflict

In most communities, veterans are honored for their valiant service to the country. Memorial services are held in remembrance of those veterans who lost their lives in World Wars I and II, Vietnam, and the Desert Storm conflict. These are the names of black Key West men lost to war. May they always be remembered for their bravery and sacrifice for others at home and abroad.

Theodore Sands graduated from Douglass High School in 1931 and went on to graduate from Florida A & M University. He served in the military during World War II and upon his return home, he began his teaching career in the Monroe County School System. Mr. Sands was a strict disciplinarian. He loved to play the piano and gave music lessons in his home. His love for educating children prompted his last request, which was for his family's home, located at 324 Truman Avenue, be developed into a museum for the children in the community. After his death in 1994, his wish was fulfilled when the Lofton B. Sands African Bahamian Museum and Resource Center, named after his father, was opened to the public in 1998. Thanks to Theodore Sands and his father, the history, culture, and accomplishments of the African-Bahamian-Cuban people of Key West will be preserved and presented for public enlightenment and the education of future generations of black children.

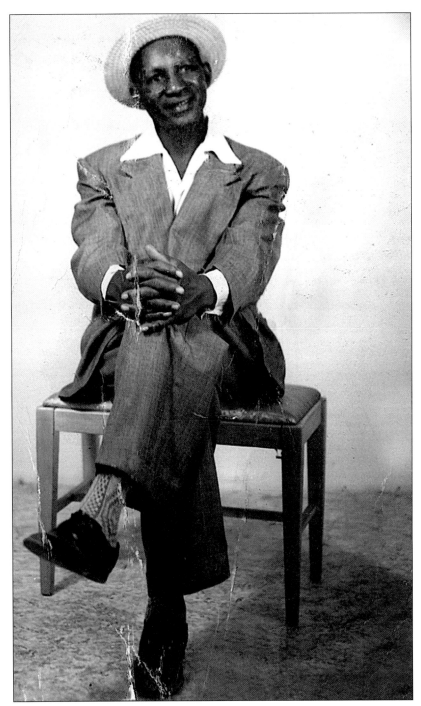

Samuel J. Sawyer was an excellent cook and carpenter. He worked as a cook in the Merchant Marines on Dry Tortugas for several years until he was hired as a ship's carpenter with the civil service at the navy yard on Truman Annex. He instilled in me a passionate love of music. My father was a "legendary medicinal bushman" and a strong example of silent patience, perseverance, and enduring love.

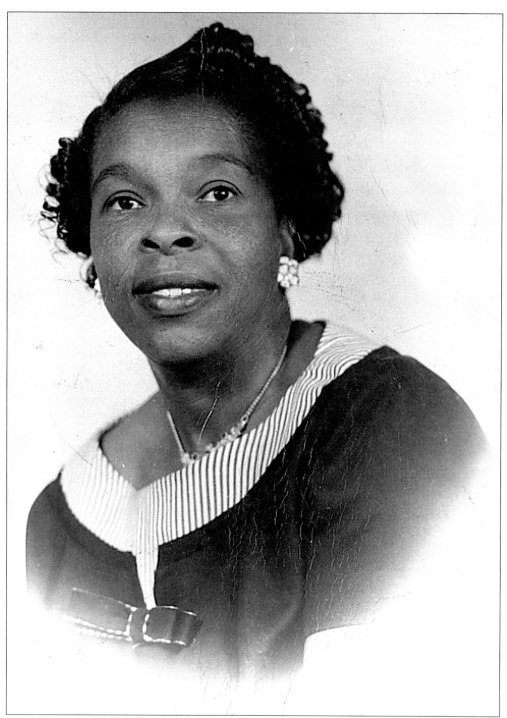

Mamie Louise Watson Sawyer was my mother and role model. She was a great cook, an excellent secretary and administrator, and a revered civic leader in our community. Orphaned at three months of age, she grew up among the elders who taught her well; she became very wise. She cultivated me and nurtured all of God's gifts she saw in me. For this, she is a legend and my hero.